talking about arabic

talking about arabic

By Mourad Boutros et al.

Mark Batty Publisher

Talking About Arabic
© 2009 Mourad Boutros et al.

All text and imagery © their respective authors and designers.

Design: Carolyn Frisch
Typefaces used: Whitney, Verdigris, Tanseek

Every effort has been made to trace accurate ownership of copyrighted text and visual materials used in this book. Errors or omissions will be corrected in subsequent editions, provided notification is sent to the publisher.

Library of Congress Control Number: 2008929888

Printed and bound in China by Asia Pacific Offset

10 9 8 7 6 5 4 3 2 1 First edition

This edition © 2009
Mark Batty Publisher
36 West 37th Street, Suite 409
New York, NY 10018
www.markbattypublisher.com

ISBN: 978-0-9795546-6-7

Distributed outside North America by:
Thames & Hudson Ltd
181A High Holborn
London WC1V 7QX
United Kingdom
Tel: 00 44 20 7845 5000
Fax: 00 44 20 7845 5055

www.thameshudson.co.uk

Contents

Foreword

Mourad Boutros

As the journey toward my second book progressed, I began to wonder who would be the best person to present an overview of the Middle East communications industry.

Today, there is plenty of creative talent in the region, but I can think of nobody better than Alain Khouri, who has remained at the forefront of the business for the last four decades. Alain was one of the first creative talents to emerge in Lebanon in 1968. It was with him that I started my career and it is to him that I owe most of my industry knowledge and success.

In the Lebanon of the late 1960s, where it all started, our designers used to rub down Letraset sheets, finalize the artwork, take it to the platemaker to produce the block (a reversed-out image, of course), then deliver it to the right media. Basically, there was no specialized person devoted to one task. There were simply things that needed to be done and we all got on with them. At that time, the three main dailies were *An Nahar* (Arabic), *L'Orient Le Jour* (French) and *The Daily Star* (English).

Alain's agency rapidly became the market leader in creativity. Alain created a campaign for the Souk at Tawile (similar to a Western shopping mall). One ad featured a man, woman and child, all naked, walking with their backs to the camera with the headline "Going to Souk at Tawile." This was followed by another ad on the following pages of the same publication with the three of them fully dressed, their faces smiling to the camera, with the slogan "Coming Back from Souk at Tawile." This campaign received many accolades. Creative ads for Beechnut-American Coffee and Casino du Liban followed, leading many other clients to give their creative business to our agency.

In the last forty years or so, Alain Khouri has gone from creative guru to Chairman and Chief Executive Officer of one of the top Middle East communications groups, operating across the entire region.

Introduction

Alain Khouri

The Middle East Communications Industry – An Overview

A Brief History

From the late 1960s onward, the lion's share of the creative work in advertising, design or branding for the entire Middle East was carried out in Beirut, where many multinationals had their regional offices. However, with the onset of war in 1975, the multinationals went back to Europe or the US, maintaining a minimal presence in the region.

For the Lebanese agencies there were only two choices: stay in Lebanon or follow the business. Some relocated to London, Cyprus and Athens, while others moved elsewhere within the Middle East. Consequently, Lebanese advertising agencies began to spread their networks all over the region by acquiring or building partnerships with local agencies, or alternatively, by establishing their own branch agencies. Simultaneously, agencies with strong links to Europe opened offices in Paris and London, doing a lot of work for multinationals from the early to the mid-1980s.

The growth of Dubai during the 1980s and 1990s focused the attention of the multinationals on regional companies. Creatives from London began to be siphoned off and, once again, the Lebanese had no choice but to follow the business. Most Lebanese media and advertising agencies now have their head offices in Dubai.

Today, most original Lebanese agencies – if not all – have some form of partnership with one of the major global brand agencies. Thus the original Impact is today's Impact BBDO, InterMarkets has morphed into Young and Rubicam, PubliGraphics calls itself Publicis, Horizon is FCB. There remain some small "boutique" agencies that continue to provide local services to small clients; but for the larger agencies, the establishment of partnerships with the major players was the natural way to develop both in terms of gaining sophistication and accessing global accounts. Over the past five years, the advent of the Real Estate, Telecommunication and Tourism & Leisure sectors as large advertisers has contributed to phenomenal market growth and to the renewed importance of purely local and regional business.

Branding in the Middle East

A brand is a symbolic embodiment of a company, product or service. Typically, it includes a name, logotype and other visual elements. It represents the aspirations and expectations of the brand owner and consumers in relation to that company, product or service. A brand is very sensitive to cultural references, local idioms and iconography.

01

02

03

Brands are also very big business. Millward Brown Optimor has created a ranking of the world's most valuable global brands using a new valuation methodology to produce its BRANDZ Top 100. Coca-Cola, China Mobile, Marlboro, Google and Toyota are among the Top Ten with Coca-Cola, for example, valued at US $44,134 million. Google tops the list at US $66,434 million (2007 figures). The BRANDZ Top 100 provides two measures of brand performance in addition to Brand Value: Brand Contribution and Brand Momentum. Brand Contribution quantifies the share of the company's earnings attributable to the brand, while Brand Momentum is an index of the brand's short-term growth.

In the Middle East, Millward Brown conducted its BRANDZ study in late 2005. The results, which were analyzed early in 2006, showed that the MBC Group, the Dubai-based broadcaster, received the highest ranking.

Contrary to what some might assume, branding is not new to the Middle East. As early as the 1920s and 1930s, several manufacturers of confectionery, soft drinks and canned food products – particularly in Lebanon and in Egypt – started branding their goods. Later on, some locally manufactured soaps, detergents, pharmaceuticals and household items also developed into major local and regional brands. With the oil boom in the late 1960s and early 1970s, both multinational and local companies sought to establish brand identities within the region. As the demand for bilingual materials emerged Arabic branding developed in Lebanon, the bridge between the Western world and the Arab world at that time. The bilingual Holiday Inn Hotels logotype (Figure 01) is a good example of that era.

After the war broke out in Lebanon in 1975, multinational companies, followed by their agencies, started moving their head offices out of Lebanon to a variety of Middle East locations, finally creating a critical mass in the United Arab Emirates, especially Dubai. The bilingual Spinneys logotype (Figure 02) as well as that of Emirates Airlines (Figure 03) are good examples of that period.

Increased Specialization
Despite the strategic importance of the Middle East market to worldwide advertisers, it wasn't until 2003 that the media and marketing-communication market truly grew. According to the latest monitored figures, the Gulf Cooperative Council markets (Saudi Arabia, UAE, Kuwait, Bahrain, Oman and Qatar) witnessed a phenomenal growth in media spending, with a total of US $4.5 billion in 2005, US $5.7 billion in 2006 and US $6 billion in 2007. Those figures do not include the North African and the Levant markets where the regional agencies are also present. This expansion is due primarily to the launch of new local and regional brands in new sectors, the continuing development of the multinationals and,

most importantly, to the increase in number of consumers benefiting from the recent oil boom.

Like their counterparts in most markets, the Middle East advertising people have also expanded across communication disciplines and have learned to provide integrated marketing services to their local and regional clients.

While we talk about the Middle East as a region, it is definitely not a single market but rather a geographic space with several common criteria. The region combines geographic diversity with demographic and psychographic variances and as is the case worldwide, today more than ever before, the Middle East is witnessing regional harmonization just as the world at large is witnessing increased globalization.

Alain Khouri is Chairman and Chief Executive Officer of IMPACT/BBDO, one of the leading Middle East Marketing Communications Groups operating across the region.

Part I: Current Arabic Design Thinking

Designing in Arabic; Nuances and Holy Influences

David Learman

Based on direct experience and written from a non-Arab point of view, the following pages are intended to give design practitioners an insider's insight to the subtleties and nuances of working with Middle East clients, creating in Arabic and communicating to Arabic-speaking audiences. To do so, we have to delve into history to establish an awareness of both the Islamic faith and Arab cultures. For all Muslims and Arab readers, I have endeavored to ensure the explanations provided about the Islamic faith and Arab cultures are both accurate and respectful. I humbly ask forgiveness should any aspect of the following be deemed otherwise. Comparisons within this chapter should be principally considered in context to the GCC (Gulf Cooperative Council) countries, which embodies a group of wealthy, stable and like-minded Arab states, although many of the issues discussed are applicable to almost all Arab states.

What is this? Why do you show this? Why do you recommend this? How long have you been here? Don't you know? You should know better – khallas! (finish!) – We have decided this is not for us!

This is a commentary I heard many times during our early days of working directly with Arab clients in the Gulf region. Disappointed by the rejection of what we thought to be perfectly positioned, Arab focused and

beautifully crafted solutions, we soon realized that we were missing something fundamentally important – our rationale, hypotheses and deliverables were not culturally aligned. When we analyzed what was going wrong, we found that while the solutions we were developing were actually very good, relevant and appropriate for the intended target audiences, they attracted criticism from our clients because, in our naivety, we had not considered or made the effort to understand or take into account their own particular cultural sensitivities and tolerances.

How many designers have attempted to sell sand to the Arabs? There are three things all Arabs hold close to their hearts: their faith, family and culture. For most educated Arabs, the love of beautiful and meaningful Arabic poetry and calligraphy sits high up on their list of cultural import. Amongst many other things, Arabs are exponents of astonishing calligraphy and typography – they have been doing it longer than anyone else and they do it better than anyone else. So, why attempt to compete with the best? Instead, we should aim to learn from their well-honed heritage, attempt to capture its essence and carry it forward into the modern day.

Lesson learned; one of the most challenging issues for anyone designing in Arabic, especially non-Arabs, is to, firstly and most importantly, acquaint oneself with

the client's cultural background, and thereafter be sure to fully understand the characteristics and persona of the intended audience, working to clearly define the values and messages that need to be communicated. A matter of very subtle cultural nuances will determine whether your creativity is a meaningful success or destined to fail before it leaves the desktop.

Many would argue that this is obvious. However, what at first thought appears to be a simple strategy is in practice, not without complication, a potential cultural minefield for the uninitiated! Over the last twenty years, the influence of the Islamic culture and Arabic language has accelerated and spread rapidly across most developed societies into the mainstream of the global community. No matter where you are located – London, Paris, Berlin or indeed on the other side of the world in the United States or Australia – awareness of Islam and Arab cultures is becoming increasingly important from a design and communications perspective. In order to understand the reasons for this, we need to consider what is happening around the world today and before we do that, take a short detour from design matters to acquaint ourselves with some very basic aspects of Islam and Arab cultures.

Firstly, we need to distinguish between what is known as Islamic and Arab cultures. To keep it simple and without going into a detailed and highbrow theological teaching, Islam is a faith and way of life as laid down in the Holy Qur'an by the Prophet Mohammed (Peace Be Upon Him). His teachings guide Muslims (followers of Islam) through their daily lives and provide guidance on how they should conduct themselves in context to each other, all inert and living things and the world at large.

Arab cultures are a little more difficult to explain. The word "Arab" is a generic term given to a race of peoples from a geographic region encompassing North Africa, the Eastern Mediterranean, the Gulf States, Saudi Arabia, Oman and Yemen. Arabs may be of any faith, they may not necessarily be Muslim and may originate from many distinctly different cultures. Today, there are an estimated 300 million native Arabic speakers around the world, ranking fourth in number after Mandarin, Spanish and English. In addition to this number, there are many more millions who are literate in Arabic as a second language.

This sounds like a very simple matter to grasp, but this is where the going gets a little more interesting. In reality, Modern Arabic per se is an uncommon language because it is characterized by what is known as *diglossia*. What this means is that modern Arabic is essentially two languages: Modern Standard Arabic (literary) and Colloquial Arabic.

Modern Standard Arabic is used in reading, writing and formal speech. It is taught in schools and used in all seats of learning. Evolved from the Classical language of the Qur'an, it is considered by most Arabs to be the "correct" Arabic. However, Modern Standard Arabic is a learned language and it is not used in everyday conversation. Most people literate in Arabic as a second language only know this form of the language. All native Arabic speakers grow up learning and using a second or "colloquial" language as their mother tongue.

Colloquial Arabic is a collective term for the many varieties of Arabic dialects used throughout the Arab world, which differ radically from the literary language. The main dialectal division is between the North African dialects and those of the Middle East, followed by that between the much more conservative Bedouin dialects. Speakers of some of these dialects are unable to converse with speakers of another dialect of Arabic; in particular, while Middle Easterners can generally understand one another, they find difficulty in understanding North Africans (although the converse is not true, due to the popularity of Middle Eastern culture, especially Egyptian films, Lebanese music and other media).

Arabic colloquial dialects are generally only spoken languages. Colloquial language is used in all daily interactions, but when Arabs encounter a language situation calling for greater formality, Modern Standard Arabic is the medium of choice. In every area of the world where Arabic is spoken, this language situation prevails: there is a colloquial language, meaning the language which is spoken regularly and which Arabic speakers learn as their primary form of communication, and then there is Modern Standard Arabic, based on Classical or Qur'anic Arabic. Modern Standard Arabic is more or less the same throughout Arab cultures compared to wide differences between the various colloquial dialects. In fact, some of the differences are so large that many dialects are mutually unintelligible. For example, it is not unusual for us to spend many hours debating the meaning and relevance of particular words or phrases in Arabic only to find that, when presented, the client has a totally different perception.

In everyday use, it is common for a native speaker to slip in and out of Modern Standard Arabic to their own dialect and vice versa. This makes life for non-Arabs and non-native speakers and readers interesting to say the least. From a designer's perspective, this results in some pretty perplexing issues. To comprehend the subtleties involved, we need to make a simple comparison.

It is estimated that the English vocabulary, for example, contains over one million words and is growing year after year, where on the other hand, the literary Arabic equivalent has an estimated 200,000 words in common day-to-day use.

The sheer volume of words in the English language provides for a highly flexible vocabulary, allowing the communication of very complex and focused messages with relative ease. In comparison, the Arabic vocabulary

is limited in the way in which complex messages (from a non-Arab point of view) can be conveyed. The nationality and cultural background and degree of literacy of the communicator will more often than not determine which form of Arabic is used.

Although there are many dialects and variants of the English language, nearly all who are conversant in both written and spoken English, native and second language speakers alike, can generally understand and communicate with relative ease, regardless of the dialects used (with the exception of those from Glasgow!). This is not the case with Arabic, where individual words have completely different meanings depending on the locality and dialect in which they are being communicated.

There are many other factors that significantly influence designers' options to express their messages, the most predominant of which is the impact of the Islamic faith on everything you do. The Holy Qur'an, as explained earlier, guides its followers through their daily lives and is their road map for life and thereafter. The influence of its teachings on Muslims is significant but is also subject to degrees of interpretation. Devout conservative Muslims consider the Qur'an literally – as a rulebook – to be strictly followed to the word without question, whereas liberal followers of no less devout persuasion follow it as a set of guiding principles.

The earliest form of Arabic document was produced somewhere around 328 AD and it was not until between 644–655 AD that the authorized version of the Qur'an was produced. The codification of the Qur'an had a significant impact; it was at this time that geometric art was established and the codification of the written Arabic language emerged, and subsequently, Arabic calligraphy, as we understand it, was born. Ever since, geometry has been the core principle on which traditional Arabic calligraphy and later typography, as well as Arabic art and architecture, have developed.

To explain why in very simplistic terms and with sincere respect, the Qur'an teaches that God (Allah) is the creator of all life and is manifest in all living things; it is forbidden to create images of any life form, because in doing so it is effectively a rendering of an image of God. Conservative Muslims believe it to be heresy to create images of any living form or of God as it is only God who has the power and right to do so.

Geometry, an ingenious solution (a science based on mathematics and physics is able to express both ordered and abstract forms), became the foundation of all forms of visual expression of Islam whether in writing, art or architecture. The concept of geometry quickly spread far and wide, wherever there was an Islamic footprint; it formed the basis of lasting reminders of the intellectual prowess and ingenuity of the Arab world. Even today, all new mosques and formal buildings are built to the same strict geometric principles and proportions as set out thousands of years ago.

Even in the moderate and relatively tolerant Gulf States, and certainly in the more conservative countries like Saudi Arabia, Kuwait and Iran, most conservative Muslims avoid the visual depiction of the human form or, for that matter, any living thing as they consider them *haram* (forbidden). You may question whether this has any bearing in today's world but the furor throughout the Muslim world, both conservative and liberal, was highly evident when *Jyllands-Posten* (a newspaper in Denmark), and subsequently others in Sweden, Holland and Spain, published cartoon images of the Prophet Mohammed (PBUH). The result was instantaneous and pitched Muslims of all persuasions into head-on confrontation with the so-called "free world." What was perceived and believed to be freedom of speech to some was and is deeply offensive and disrespectful to others. This should be a sufficient warning to anyone who may forget, or wish to challenge, this core principle.

This said, the many creators and innovators throughout the ages have developed geometric pattern design and both Arabic calligraphy and typography to such an extent that the medium itself, which was created to avoid the depiction of literal images of life forms, may be configured in such a way as to articulate recognizable living things. Examples of this are the use of Kufic and Naskh scripts to form both intricate designs and calligrams of all manner of life forms.

In modern times, the influence of Islam and Arab cultures has grown at an incredible rate and has been accelerated over the last fifteen years in particular, by many events both good and bad, the reasons for which are many, but principally driven by the political and tangible needs of consumer nations to secure sources of oil and its by-products to meet their insatiable demands. As well as causing significant political unrest, this has driven the cost of oil and its derivatives to unprecedented levels and has resulted in an astonishing growth of wealth across most Middle Eastern and other oil-producing states. On the counterbalance, the oil-producing states have never had such a massive bonanza with subsequent revenues far exceeding their fiscal budgets year on year. Driven by a realization that the golden goose may one day expire, many are investing large proportions of their surplus cash on acquiring all manner of assets around the world.

Historically, in many Arab states, a large proportion of their oil revenue was spent on military hardware and distributed by rulers to a favored few to maintain loyalty and political support. However, some state leaders have been more visionary and conscious of the need to secure long-term benefits for their people, investing much of their wealth into creating sound economic and national infrastructures. Through years of careful planning and

single-minded commitment, these investments are now paying dividends and virtually all the Gulf Arab states have relatively sound socio, economic and political platforms in place. Much of the required expertise and intellect have been imported, and with it, new aspirations and visions have evolved. The Arabs have learned much about the wider world, and in particular, how it does business. Cherry-picking what could be perceived to be the best case examples around, Arab entrepreneurs have shrewdly repositioned their businesses to not only maintain appeal to their customary Arab audiences but also to new international non-Arab markets alike. On the outer surface, all of these businesses appear to be similar to their non-Arab international counterparts but what makes them different are underlying and inherent cultural philosophies.

Over the last twenty to thirty years, a large number of young Arabs have graduated from some of the best universities the world has to offer. These young men and women have traveled back home with an enviable understanding of the wider world combined to varying degrees with that of their own cultures. They have come to appreciate much of what they have learned and experienced of different cultures, from all aspects of life and the arts to economics and commerce. They are a new demographic, blending new ideas and ways of doing things with their inherent cultural values. Many of this generation of "new" Arab thinkers are now leading their family firms and are driving them with unprecedented vigor. In doing so, they are innovating and creating new dynamics through the application of their unique perspectives on the order of things.

In particular, there appears to be a collective desire to build economies and businesses that appeal to international audiences on social and ethical principles drawn from Islam and the Arab values. This is very obvious in Dubai, where today a number of "home-grown" businesses are now world leaders in their sectors; these include Emirates Airline, Jumeirah, DP World, Emaar and Istithmar. Although to the outside world, they do not appear to be so, these organizations are in every sense of the phrase "global players" built on the foundations of Islam and Arab cultures.

From such examples an interesting trend can be observed. Most Gulf-based organizations and businesses with international aspirations are eschewing the use of Arabic in their corporate and brand marks, using English as the preferred language. This use of English is prevalent through most levels of commerce with the exception of government departments which, in many instances, have taken on the mantle of protecting their national cultures, insisting that all government communications are in Arabic (supported in most cases by an English translation). In some countries, this sense of cultural protection goes

فــنــدُق حــصــنْ حَــتَّــا
Hatta Fort Hotel

to the extreme of requiring all communications (written and spoken) with a government department to be only in Arabic, whether applying for a trade licence, acquiring a visa or any other statutory documentation. This also happens to be the case in the legal profession and judiciary, where in nearly all the GCC states, no language other than Arabic is recognized and a written document is not admissible in law unless it is drafted in Arabic.

This phenomenon is creating a completely new language. Many of the new names currently entering the marketplace are neither Arabic nor English but a combination of the two. For example, a name is brainstormed in Arabic and then translated phonetically to English, resulting in a hybrid word that crosses the cultural divide. From a brand creator's and marketer's point of view this opens the door to a whole new world and addresses the needs of a broad range of businesses wishing to reach young, liberal Arab audiences. Not only is English being used increasingly in brand naming and communications but it is also becoming the lingua-franca for many other expatriate, non-indigenous populations present in the region. What is fascinating is that other languages are being manipulated in a similar way and to such an extent that examples of Chinese Arabic and Japanese Arabic hybrids are starting to appear.

Today, there are more cultures present in the Middle East than almost anywhere else on the planet. This melange creates both challenges and opportunities for designers, marketeers and communicators alike. Because of the diversity, and the fact that many are taught it as a second language, English is probably as widely spoken as Arabic. Traveling along any of the major highways in the region, you will notice a profusion of outdoor advertising in English; the more conservative the country you are in the more Arabic you will see and vice versa. The extent to which English has taken hold in the region can be judged by the number of major Arab organizations and businesses that use it unilaterally throughout their branding, communications and business operations. Some typical examples include semi-government-owned entities like Dubai Holding, Emaar and Jumeirah.

These organizations are principal corporate icons of Dubai and are working to create examples of how new thinking, wealth and innovation can be applied successfully within the restraints of Arab cultural boundaries to the indigenous private sector and to commerce across the wider world. Indeed, it is not about working within the restraints of Arab cultures but a demonstration of how the principles of Islamic and Arab cultures applied in an innovative way, can create world-beating enterprises.

This brings us onto understanding Arab audiences. For a non-Arab this is perplexing to say the least. The nature of Islam and Arab cultures is to be humble and non-effacing, which presents a whole box of challenges in

itself. No matter how much research you may undertake, trying to establish a reality is difficult as in some countries women have few rights, in others few have anything to do with running the household or purchasing decisions, as often in the more sophisticated levels of society most of this is undertaken by maids or housekeepers who are from as far away as Indonesia, India or the Philippines. When trying to establish audience motivators and triggers – especially when dealing with staples and FMCG brands – it is these far-flung cultures we need to explore. Their influence in the household is such that many Arab and Western expatriate youngsters speak with foreign accents and unusual dialects.

It goes against Islam and Arab cultures to boast or indeed speak about anything that may be deemed to be about private family affairs, assets and achievements so gleaning useful and qualified knowledge about the inside workings of the family is a complex.

This is where a close client relationship is important and can pay dividends, as clients often have an intrinsic understanding and can provide cultural insights that would take a lifetime to research.

We are at the end of the detour. But, where are we? Well, without doubt, the first important lesson to learn is to know your clients. Get inside their psyche; get to know whether they and their advisors have conservative or moderate religious views; explore their attitudes to what we, as non-Arabs, deem to be everyday topics and establish the basic ground rules for an ongoing and enduring relationship. In the Gulf, this is relatively easy to do because of the way in which business is done. More often than not, the first two to three meetings with a prospective client are not about business but establishing a chemistry and an understanding of each other. If your style, approach or attitude is perceived to be inappropriate then it is unlikely you will be invited to bid for a job. Should you like to learn more you should read a book called *Don't they know it's Friday?* written by Jeremy Williams (published by Motivate); it is an invaluable insight to cross-cultural considerations for business and life in the Gulf.

Personally, I have experienced only one or two occasions when I have fallen victim to the nuances of Arab cultures. On one notable occasion, I attended the office of a highly prominent Arab businessman at the appointed time to be welcomed by a secretary and offered the customary Arabic coffee and dates. After waiting several hours, I was ushered into an inner waiting room and waited a further hour and a half, during which further lavish hospitality was extended by another secretary. Only after I inquired how much longer I should wait was I told that my meeting was postponed because it was such a good cool morning, the Sheikh had decided to go to the desert with his friends to fly their falcons! One must not forget that in the Arab world there is a different set of

priorities by which business operates.

Next, involve your client in your project processes. As previously explained, one must not forget that most have graduated with the highest qualifications and grades from international universities and that the majority of modern-day Arab business people are worldly and highly intellectual. They enjoy expressing their cultures and being involved in creative debates especially relating to rationalizing the merits of a particular recommendation. At this point it should be mentioned that this love of debate is cultural. By tradition, most Gulf Arab business people are highly cautious and decisions are not usually made alone or without much discussion with family or friends and often within the *Majlis* where individuals entertain and council their peers. For non-Arabs the *Majlis* is a place for deep concern for this is where all control over the development and decision-making process is often lost and from which clients will return with either an unequivocal approval or more often a total compromise where the integrity of the original idea has turned 180 degrees!

A review of the corporate and brand identities emanating from the Gulf region demonstrates a predominance of either word marks or marks constructed with abstract shapes or lines. This is because of either conscious or subconscious influence of the client on the designer, or indeed, created by designers of Arab descent, with the aim of avoiding offense. Unfortunately, many such examples exist and the number is growing by the day. As regional markets become increasingly competitive, the greater the profusion, the greater the confusion and the more difficult it is to differentiate between such branded offers.

In the past, advertising agencies were recognized as being the only source of creativity in the region and offered a one-stop solution to clients wishing to undertake any form of brand creation or development through to communications. Today the scene is changing and is being driven by a client base that is becoming more sophisticated by the day, and is aware of the benefits of working with highly specialized firms. In order to achieve an international flavor, many of the region's super brands and businesses have sought design consultancies from outside the Middle East to provide brand development strategies and new vision to identities with the aim of positioning them in the world order.

This influence is very typical of the direction in which the design profession is heading in the GCC. Many Western and Far Eastern influences are making a mark in the market through the need of regional commerce to appeal to a wider non-Arab world to such an extent that most of the world's leading brand and design consultants have or are planning to set up offices in the region. With this shift, a new breed of designer is starting to emerge in the region, one that has an inherent understanding of Arab cultures and a sense of the direction in

which they are going, together with an ability to conceive and apply sophisticated brand and communications solutions garnered from the wider world.

By combining the acceptable values of a number of cultures with their own they are creating a new order and establishing a cutting edge. The wind of change is bringing new innovation and new ways of thinking but without doubt, everything is and will continue to be influenced in the background by the Islamic faith and Arab cultures.

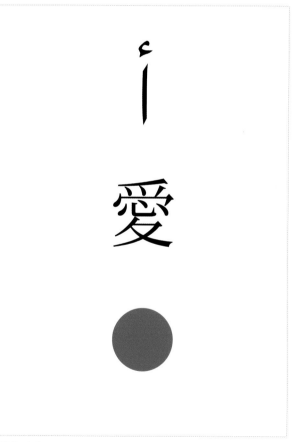

Stéphanie Farran
Direction Artistique, Artistic Direction; Third year
Original title: I love Japan (mixed Arabic and Japanese)
English translation: I love Japan
Explanation: Inspired by Milton Glaser's campaign for New York City, I decided to create the same atmosphere for my poster using the "I" written in Arabic, the word "Love" written in Kanji and the red circle, the emblem of Japan.

Teaching Arabic Type Design in a Global Context

Halim Choueiry

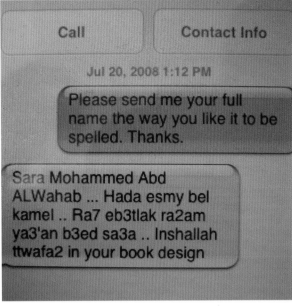

01

02

01 Mobile phone message that shows how numerals are used as letters for Arabic words.
02 A tri-lingual signage system at Beirut International Airport in Lebanon. Photographer: Halim Choueiry.

A Global Introduction

While globalization has made its impact all over the world on multiple levels, many experts contend that it is the Middle East that has experienced the most change: "No part of the world has come into the global market more rapidly and with more change in material abundance than the oil states along the Arabian Gulf."[1] The rapid transformation of desert towns and seaports into commercial and cultural centers busy with trade has led to the inevitable phenomena of cultures that "[tend] to make representations of foreign cultures the better to master or in some way control them."[2] Those ideas of modernization and globalization and their erosion of, and opposition to, traditions and local (cultural) identities, and questions of how much one can or should be open to the world, have given birth to developments in practically all areas – social, economic, recreational, political – and therefore have left the Middle East wide open and, in a sense, vulnerable to many social interactivities and changes that maybe are not necessary, or beneficial.

In his book, *The Lexus and the Olive Tree*, Thomas L. Friedman suggests, "globalization is a forceful ongoing process of merging of the world's markets through the application of new technology."[3] Since the early 1990s, it has become evident that the process of globalization "has effects on the environment, on culture, on political systems, on economic development and prosperity, and on human physical well-being in societies around the world."[4] In regard to globalization, human strategies are diverse: "Some attempt to stop or slow down aspects of globalization, while others aim to reshape its path in ways that promote democracy, equity and sustainability."[5]

There is no doubt that globalization benefits countries with new cutting-edge technologies and high-level communication means. This pushes us to reflect on how important our local culture and national language and identity are vis-à-vis this new influence. As Jaber Asfour points out: "We should not resort to preserving identity in its form of origin, but rather use it as a potential for creativity."[6]

Take this example from the crossroads of cross-cultural exchange: first generation mobile phones. When created, there was an absence of the Arabic Interface, forcing people to send text messages using the Latin alphabet to express Arabic words. But, not all Arabic letters have matching phonetics or equivalent letters in Latin. To get around these linguistic handicaps numerals from 0 to 9 (which, in the first place, are called "Arabic numerals" because of their origin) were inserted between regular letters in order to produce the correct pronunciations. An interesting phenomenon was born through this new typographic representation. With the extensive use of mobile phones, and the internet, this phenomenon escalated gradually. (Figure 01)

Even after the introduction of the Arabic Mobile Interface, people kept spelling words with Arabic numerals, essentially creating a hybrid language based on technological limitations that became habit. Where numerous designers, typographers and thinkers did their best working on Arabic typography trying to simplify its usage, visual representation and make it work harmoniously with Latin typography, technology bridges this gap in a very unique way. Is this new typographic usage going to be the new trend? And to what extent will this influence Arabic typography or shape its usage, if at all? What are the cultural implications and the future trends of communication (keeping in mind that even if those numbers are used in the West, their roots generated and are embedded in Arabic and are still being used with the Arabic text in various communication mediums)? Questions looking for answers...

A Closer Look

For just over a decade, the Middle East's populace "[has] been accustomed to a sharp division between East and West, modernization and tradition and national identities and the conditions of being open to the world."[7] For the past century at least, this same populace has been importing to the Arab world what has been produced by the West, whether they deemed it necessary or not. This has also resulted in many people growing accustomed to speaking two languages – and in Lebanon most people speak Arabic, English and French (Figure 02) – to the point of switching between and integrating Latin words into their everyday conversation, naturally as if it is a normal part of the language they speak. Some countries in the West, like Belgium for example, have already started integrating Arabic as part of their signage system (Figure 03) for the agglomeration of their Arab communities. And the funny thing is that some Arabs who want to go international transliterate words from the English language to use it on their signage systems and spell it out the way their Arabic phonetics work for them.

 People in the Middle East, perhaps due to never-ending Western colonization, welcomed and absorbed what they found compatible with themselves and tried to identify what was not. This amalgam resulted in creating a new cultural identity for the people of that region that was much more in harmony with Westernized social and cultural mores. This doesn't mean that people became Westernized, or that they lost their traditions completely. Rather, a new specific cultural identity has been created.

 The authors of *Globalization and the Gulf* put it best: "The Arab Gulf region: Traditionalism globalized or globalization traditionalized?"[8] (Figure 04) This question, as succinct as it is, really only leads to many, many more questions. A blurred cultural identity has been created by these imported patterns and we are not yet sure of the

03

04

03 Bilingual signage system in Belgium. Source: Chain email.
04 Westernized signage system with a crossing figure wearing the local Qatari dress, the Dishdasha. Photographer: Halim Choueiry.

05

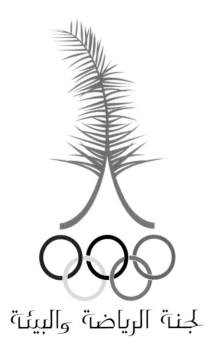

06

outcome. And all those signs and signifiers are also not helping us to understand, define and determine the role of those created patterns.

Typography

It is within this context that we examine Arabic typography and type design. When Guttenberg invented movable type, Arab calligraphers were not part of the innovation. This has meant that, until relatively recently, all of the developments and innovations surrounding typography and the technologies of typography have not taken Arabic typography into account. Over the past twenty-five years or so, this has certainly changed, but the fact remains that Arabic typeface development has been playing catch-up.

Identifying the challenge and the need to match Arabic typography with Latin typography, a new trend began to emerge, first in finding Arabic typeface designs that could work with Latin typography so that the two could exist in harmony on the same page. The need for such typographic developments truly came to light during the 1970s and 1980s in the form of branding. Western companies breaking into Arabic-speaking markets needed to convert their logotypes into Arabic, while still maintaining their corporate identities. A new trend was born: converting words from Latin alphabets into Arabic words. Kevin Roberts, of Saatchi & Saatchi, describes his experience in the Gulf with the Arabic branding of products that were imported to the Middle East as such: "In Arab countries you make friends for life. The people were genuine, emotional, family focused, hospitable. They understood their traditions and the past, and they really understood that they had a completely different future... There was little resistance to the new because they didn't have much of a present. They had a past and they had a future."9

The Universities

There is no control over vernacular design. (Figure 05) It speaks freely and is born from the culture around it. And that is the beauty of it. There are no rules, regulations or visual studies, just intuition and expressions of needs. Universities, however, responded to the Arabic/Latin mix in a different manner. Professors involved in bilingual typographic considerations started identifying this trend as a must for the global societies in which they lived. The conversion of Latin typography into Arabic typography grew popular. Methods for conversions started to be identified, detected and implemented. Typographic courses became placeholders for such activities as well as Design Systems and animation classes. The natural growth of such activities resulted in attempts to create original typefaces. Typography courses provided the right environment to develop such exercises, especially since the need for such innovations was, and is, in great demand. (Figure 06)

لجنة الرياضة والبيئة

Sport and Environment Committee

07

Ways of Doing

Basically, there are two ways or methods to work on an Arabic typeface. The first and most common one is the conversion of a Latin typeface into Arabic that is in reach of every designer, and the second one is to create an original typeface from scratch, which is more complicated and requires a higher level of typographic expertise. By scratch it is meant from any object, item or any similar inspiration that might tackle the creative brain.

The Process

Like all creative endeavors, it is hard to say that there is a single system or way to achieve the final goal (in this case converting a Latin typeface into Arabic). Below, the description provided is a general outline that many designers follow. No matter what process a designer feels works best for him or her, what is imperative to keep in mind is that for a truly successful conversion, the designer must have a thorough knowledge of Arabic.

Converting Latin into Arabic

When converting a Latin typeface into an Arabic one, the process can be generally described as one that aims to preserve the look and feel of the Latin typeface, creating a visual match or cohesion between the two. One common first step is rotating letters, twisting and tweaking them, until they resemble Arabic ones. (Figure 07)

For example, if a lowercase "m" is rotated 180°, it becomes the first part of the letter *seen* in Arabic. And so on…(Figure 08)

The use of punctuation marks and numbers can sometimes also be helpful. Such as (parentheses), interrogation and exclamation marks (?!), greater than less than signs (><), etc. …

This sort of exercise usually starts by typing, both in upper case and lower case, all of the Latin letters being used that will be converted and then starting to identify the shapes, lines and curves that could easily be manipulated in order to achieve the requested Arabic letterforms. The trick here is to know how to connect these letters together, since Arabic is written as a connected script, without damaging the main look and feel of the original typeface while also maintaining the sense of harmony that Arabic requires. (Figure 09) This needed sense of harmony originates from the calligraphic nature of Arabic and having a deep knowledge in the calligraphic styles and subject is strongly recommended when such an exercise is being attempted.

Advantages

The advantages of such an exercise are obviously the preservation of the strokes' width of the letters in question, their thickness, width, curves and the small details that give a typeface its uniqueness, elegance and visual

ABCDEFGHIJKLMNOPQRSTUVWXYZ
abcdefghijklmnopqrstuvwxyz
1234567890 ,<>.;':"/?\|}{[]

لجنة الرياضة و البيئة
Sport and Environment Committee

Ⅎ σ m ʝ 2 D P u Q I
ʕ ƨ ɯ ʃ ᗡ ᑫ ɾ ⌐ ʔ
ط

08

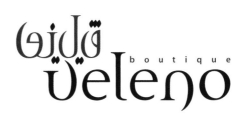

09

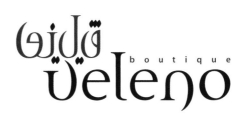

05 No control over the vernacular. Parking sign in Beirut, Lebanon. Photographer: Halim Choueiry.
06 Arabic typefaces as part of the Type 3 class at Virginia Commonwealth University, School of the Arts in Qatar. Class taught by: Halim Choueiry. Student work shown by: Eman Youssef, Maha Al Sada, Ghada Hamed, Farah Al Ali, Mashael Al-Thani, Mounira AlBadi.
07 The conversion into Arabic of the Sport and Environment Committee typeface. Converted by: Sahar Mari.
08 Example of how Latin letters can be twisted around and converted into Arabic letters. Converted by: Sahar Mari.
09 Bilingual logotype for Veleno Jewelry Boutique, Doha, Qatar. Designed by Halim Choueiry and Sahar Mari.

10

11

12

10 Tire imprint. Type 3 class at Virginia Commonwealth University, School of the Arts in Qatar. Class taught by: Halim Choueiry. Student work shown by: Anahita Soleymani.

11 Experimentations and enlargements. Type 3 class at Virginia Commonwealth University, School of the Arts in Qatar. Class taught by: Halim Choueiry. Student work shown by: Anahita Soleymani.

12 Early rough shapes of Arabic type. Type 3 class at Virginia Commonwealth University, School of the Arts in Qatar. Class taught by: Halim Choueiry. Student work shown by: Anahita Soleymani.

style. Starting with a select set of letters can also result, of course, in the creation of a complete Arabic character set that matches the Latin one.

Creating a Totally New Typeface

When creating a totally new Arabic typeface, whether decorative, for titles or for body text, the process is much more complicated but the successful results are unique. Any source of inspiration can be used as a starting point: any object, item, artifact – from tree leaves and branches, to pliers, orange squeezers and sleeping dogs in various positions. Creativity has no limitation and anything can be the source for creating a new Arabic typeface.

The creation process can start in the dissection of the chosen object, considering the object and its flexibility, limitations and movement (if any). For example, if the imprint of a car tire is chosen (Figure 10), one of the approaches to experimentations is the dissection of the pattern by taking it to the photocopier and making enlarged copies of its texture. Or, paint it with gouache paint and use it as a stamp on plain white paper. There is no limit to how many enlargements one can make, or how many clone stamps one can do…that depends only on the designer's vision and chosen method. (Figure 11)

At this stage, the results of the various experimentations with the object in question need to be analyzed visually in order to identify various letterforms. The letterforms at this stage are rough shapes of what can resemble Arabic or calligraphic letters. (Figure 12) And this is the whole idea behind it. Keeping the designer's mind open, and teaching him or her how to see things, in this case letterforms, where they are least expected.

When a selection of letterforms is identified, the designer chooses the ones that most appeal to him or her, or a set of shapes that contain the most interesting features or styles that can be advanced so as to, eventually, have a working typeface. (Figure 13)

Now the actual work starts. The chosen letterforms need to be drawn in the software that the designer is comfortable with. It is not expected that the designer uses Ikarus, for example, but a vector-based software is a must for the drawing of the original shapes. While tracing the shape, the twist on which this letterform was chosen should be carefully preserved or highlighted. (Figure 14) There is some refinement that needs to be introduced at this stage, in order to obtain a clean form for a letter. But mind you that in some cases this might not be the final shape and additional changes might need to be done, depending on the how the development of the other letters is taking shape. It is a kind of a revisiting process and nothing is set in concrete until the satisfaction with the final result. (Figure 15)

When this primary satisfaction of the traced letter is obtained, a grid needs to be built on top of it in order

to start tracing the other letters of the alphabet. The grid should be thorough, enabling the identifications of the connection points between the horizontal strokes and the vertical ones, as well as the curved lines and their respective radii. (Figure 16) The role of the grid is to assure the harmony among the various letters that need to be designed. The grid will also help to maintain the consistency in the proportions of the letters as well as the thicknesses and the relationships of the curves and radii.

Throughout the process of developing and designing the letters, the doors are always open for modifications and changes in order to assure a better result. When designing, new changes to accommodate the letter's specifics, or sometime even accidental designs, will surely emerge and might add another interesting layer or a better visual aesthetic; the designer might judge that this is something good to have and therefore adjust all the other letters accordingly. The process of design is open and creativity has no limit. (Figure 17)

It is most important in the final analysis to have a completely designed typeface and that should include all the letters, depending on if they stand alone, or at the beginning, middle or the end of the word. (Figure 18)

Once all of those letters and their related punctuation marks (parentheses, commas, diacritic dots, *kashidas*, etc.) are all designed, the typeface needs to be digitized so it becomes ready for computer use. There are a couple of companies that specialize in doing this and they can be contacted for digitization and distribution of the typeface later on. (Figure 19)

Advantages
The advantage of creating a typeface from scratch is the freedom of creativity in the obtained results. This creative process permits a learning curve that can be altered later on for further developments. The flexibility to alter the curves, lines and letters' thicknesses is totally free and not related to any Latin typeface that needs to be followed. The organic nature of calligraphy can be respected, analyzed and applied creating a visual dialogue between the texture of the tire imprint and intuitive creative process itself.

Key Issues and Common Mistakes
No matter how you go about it, a knowledge of traditional Arabic calligraphy is essential. It is this knowledge that will define for designers the respective spatial relationships of the various letters that was devised by Abu 'Ali Muhammad Ibn Mouklah, a 10th-century calligrapher responsible for consolidating and systematizing the major Arabic calligraphic styles using three standard units: the rhombic dot, the Alif and the circle.

It also shows that even if some letters have a visible difference in the number of their diacritic dots, they are actually also different in the ways they are written. For ex-

13

14

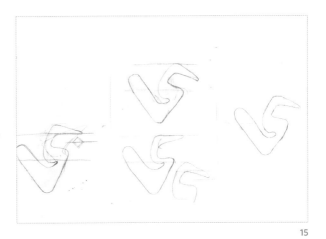

15

13 The chosen letter. Type 3 class at Virginia Commonwealth University, School of the Arts in Qatar. Class taught by: Halim Choueiry. Student work shown by: Anahita Soleymani.
14 Adjustments and refinements. Type 3 class at Virginia Commonwealth University, School of the Arts in Qatar. Class taught by: Halim Choueiry. Student work shown by: Anahita Soleymani.
15 Adjustments and refinements. Type 3 class at Virginia Commonwealth University, School of the Arts in Qatar. Class taught by: Halim Choueiry. Student work shown by: Anahita Soleymani.

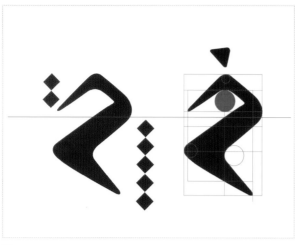

16

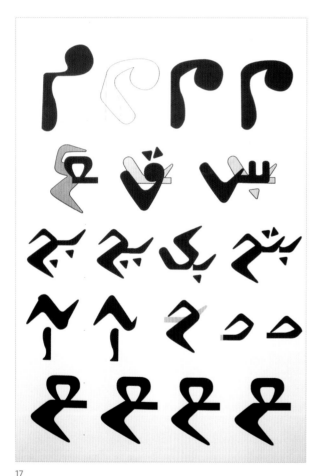

17

ample, a very common mistake is keeping the same shape of letter for both the *Kaaf* and the *Faa'* and just add one more diacratic dot to make the difference. (Figure 20)

Personally, I don't think that Arabic should be matching Latin typography. Not that I didn't do it when I was at the beginning of my career, because I did. But when I started really analyzing the nature of Arabic and all of its culturally embedded connotations and layers, I realized that there is no need to make the two different typographies match. Rather, I felt it better to make the two different cultures come together at the same time and exist in harmony rather than stripping one of them from its specifications and uniqueness. Co-existing together in harmony while keeping the differences and the unique-ness of each culture preserved is much more interest-ing to achieve. Just like in life actually, when we have a cross-cultural situation that we are trying to work with or understand how it functions. Following the West is not always the right solution, besides I would like to see the West following the Arab traditions for a change.

Endnotes
1, 2, 8. Fox, John W. Mourtada-Sabbah, Nada. Al-Mutawa, Moham-med. *Globalization and the Gulf*. Routledge, London, UK, 2006.
3, 4. Friedman, Thomas L. *The Lexus and the Olive Tree: Understanding Globalization*. Anchor Books, New York, USA, 2000.
5. Anderson, Sarah. Cavanagh, John. Lee, Thea. *Field Guide to the Global Economy*. The New Press. New York, USA, 2005.
6. Asfour, Jaber. *An Argument for Enhancing Arab Identity with Global-ization and the Gulf*. Routledge, London, 2006.
7. Tohme, Christine. *Home Works: A Forum on Cultural Practices in the Region*. Ashkal Alwan, Beirut, Lebanon, 2003.
9. Roberts, Kevin. *Lovemarks: The Future Beyond Brands*. Powerhouse Books, New York, USA, 2004.

16 Grid development. Type 3 class at Virginia Commonwealth University, School of the Arts in Qatar. Class taught by: Halim Choueiry. Student work shown by: Anahita Soleymani.
17 Final adjustments of letters. Type 3 class at Virginia Commonwealth Uni-versity, School of the Arts in Qatar. Class taught by: Halim Choueiry. Student work shown by: Anahita Soleymani.

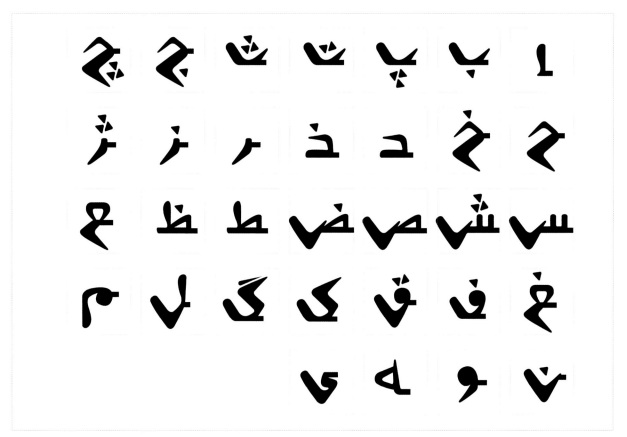

18 Various letter shapes, depending on their position in the word. Type 3 class at Virginia Commonwealth University, School of the Arts in Qatar. Class taught by: Halim Choueiry. Student work shown by: Anahita Soleymani.

19 Sample of written words. Type 3 class at Virginia Commonwealth University, School of the Arts in Qatar. Class taught by: Halim Choueiry. Student work shown by: Anahita Soleymani.

20 Examples of Qaaf and Faa and their differences. Type 3 class at Virginia Commonwealth University, School of the Arts in Qatar. Class taught by: Halim Choueiry. Student work shown by: Mashael Al-Sulaiti.

Multilingual Web Design

George Kandalaft

Compared to the long history of printing, the World Wide Web is still in its infancy (it was created by Tim Burners-Lee in 1989, but it was not until 1993 that the Web started to spread). But it has come of age since, and today the technologies underlying it allow us to publish material with a standard at least as appealing as printing but at a much lower cost.

There are two major aspects that characterize the creation of a Web site: the application that delivers the information to the visitor and the design that makes this delivery appealing in terms of aesthetics, ergonomics and interactivity.

Many technical advances contributed to the rapid development of the Web, but some of them had a direct impact on the design aspect of the sites, as they allowed a wide range of opportunities and rid the designer of a number of constraints that would limit their freedom of creation:

◊ the increase in data-transfer speed, due to the widespread availability of broadband connections, gave the designer more freedom in creating media files such as images and animations with sizes more suitable to their content and allowed the visitor to download them with greater speed

◊ the technical progress of display cards and screen resolution allowed the display of millions of colors and sharper texts at a higher response time

◊ the introduction of Cascading Style Sheets (CSS) in Web design separated the content of a Web page from its layout and gave the designer the freedom that desktop publishing applications provide for designing pages

◊ the development of Unicode character sets turned the Web into a true multilingual platform

◊ the introduction by the World Wide Web Consortium of multilingual recommendations and instructions into the Web standards and the increasing support of those recommendations by Web browsers.

Thanks to these technical advances, non-Latin sites witnessed a tremendous increase in their numbers at the beginning of the 21st century. Scores of Arab internet users still remember the heroic time when site creators had to convert pages of Arabic text into GIF images to display them on the Web as did the *A Sharq Al Awsat* newspaper and *Ad Diplomasi News* report in their early days, before moving to real Arabic texts, when browsers started to support the different character sets that define Arabic and the recommendations of the World Wide Web Consortium about the language character sets and the bi-directional tags.

Despite the dramatic increase in the number of Arabic sites since the introduction of the Unicode character set, the design quality of those sites remains, for the most part, poor.

Although all of the tools and tags are available to build highly professional Arabic or bilingual sites from scratch, the main reason for this state of affairs comes from the availability of ready-made solutions to the various activities that we find in Web sites today: there are ready-made Content Management Systems (CMS), blog creation systems, forum creation systems, etc.

While the majority of those systems allow the users to create their own personalized templates for their sites' Web pages, they all come with a set of default templates that are basically just examples of what the systems can do.

Another characteristic of those systems is that they were all developed in the West, in the context of Latin typography, which means that the basic templates that they provide are designed for left-to-right pages with Western design specifications.

Here lies one of the main problems with most Arabic sites: a quick survey of popular, heavily trafficked Arabic sites reveals that the vast majority of them are either forums, blogs or electronic magazines. Such sites rely heavily on ready-made systems, not brand identity sites that promote companies or organizations. The systems themselves are not really on trial here, as hundreds of thousands of sites use them successfully, but the Arab developers who use them are. The fact of the matter is that although there are large numbers of good Arab developers around, and most of those systems are open-source solutions, hardly any Arabic developer seems to be interested in localizing the kernels of those systems so they can genuinely support Arab sites. They just use those systems to build sites that rely heavily on the Latin features of the underlying kernel, save the introduction of the right-to-left (RTL) property in the main tag of their sites, a logo designed in five minutes and a change of colors (sometime) on the default template pages. Oh yes! And loads of flashing ads and scrolling texts all over the place, which is by any standard, unprofessional. The result being hundreds of look-alike sites very poorly designed in terms of aesthetic, ergonomics and bi-direction handling.

As for Arabic sites aiming at creating a true identity or content, most of them create Latin sites and then just adapt them into Arabic, maintaining the "Western flavor."

The main responsibility for this state of affairs falls primarily on Arab developers and designers, the latter not yet freed from the grasp of the printing industry.

But Arab developers and designers are not to blame for every problem facing Arabic Web sites. The responsibility of one of the major problems lies at the feet of operating system developers, namely Microsoft, since its operating system, Windows, is at the heart of most computers.

It is well known that operating systems come bundled with a set of fonts used to display the system's User Interface and allowing the user to start working even before they have to install their own applications and fonts. And those are the same fonts that are used to display text on Web pages, which means that Web site developers create their sites by limiting the use of fonts to those that are installed on all visitors' computers, taking into account Windows, Macintosh and Linux platforms.

It also means that a site developer cannot use a font he knows is not installed on all computers, which leaves Arab developers with the Arabic fonts installed by default with the operating systems. And since Windows is the most widely used platform, Arabic Web sites are reduced to show three basic fonts: Arabic Transparent, Simplified Arabic, Traditional Arabic and Tahoma (a Unicode font). All four options are of very poor quality. That does not mean, of course, that other operating systems offer much better fonts but the most popular system is naturally the most open to criticism.

As for Web browsers, their rendering of Arabic fonts leaves much to be desired. As a result, some site developers are reduced to use bold text only on their page to make this text legible.

Things get worse when we come to multilingual sites, and more specifically, bilingual sites. We will only refer to bilingual sites when they involve any Latin or non-Latin (Cyrillic for instance) left-to-right language with any non-Latin right-to-left language (like Arabic and Farsi) as those opposite directions are one of the major concerns of site designers and developers. For this sort of site, proper design and page and text directions are crucial.

It is simple enough to control both directions in a bilingual page if left-to-right blocks of text are distinct from right-to-left blocks, but things can get awkward when both languages are intermingled as you have to control directions block by block. Unlike desktop applications where this problem had been solved for quite some time, with site-design tools like HTML and CSS, things are still done by hand, which means that the burden of harmonizing both languages on the same page falls on the developer. It is therefore the developer's task to introduce direction control smoothly in any site content solution.

This task and other design tasks for multilingual content are achieved without problem on custom-made sites (e.g., sites that are not based on ready-made solutions), but as we said earlier, those sites are at the bottom of the popularity scale as the most visited sites are blogs, magazines and forums that are mostly based on management systems that are readily available and are mainly open-source and therefore free and opened to developers to improve them.

Unfortunately, developers of those systems are not very much interested in Arabic localization and it is up to Arab developers to come forward and contribute to the improvement of multilingual features, which they scarcely do.

This leaves us with a situation where Arabic sites based on open-source systems are very poorly designed, but most dangerous, contributing largely to the fact that visitors are getting used to this poor design, accepting it as the norm.

SPIP Case Study: A True Multilingual System

Because forums, blogs and e-magazines are the most popular sites using Arabic, we will concentrate on the systems that manage them.

A true multilingual system is a system where all languages, and therefore both reading and writing directions, are treated equally.

There is no need to reinvent the wheel to build such a system. A truly dedicated team of developers can take any of the popular ready-made systems and modify them in such a way that they become truly multilingual, especially since the most popular systems are free and open-source, meaning that their codes are freely available to developers.

Of course, for such a system to become truly multilingual, the idea has to be agreed on and accepted by all those who contribute to its development. If one or more persons decide suddenly to introduce multilingual support to an existing system, they have to be supported and helped by the developers already working on this system, otherwise their contribution will remain isolated and confined to perhaps one version of the system and most probably abandoned by the next version.

SPIP (Système de Publication pour l'Internet, the meaning of the last "P" is still controversial) is a Content Management System (CMS). (Figures 01, 02) It was developed in 2001 by the French Minirezo (a group advocating the Independent Web and free speech on the internet) to manage the content of their site.

SPIP is dedicated to managing electronic publications like magazine and newspaper sites and emphasizes collaborative work. As a matter of fact, its back-end area is an actual newsroom where contributors can post their articles, discuss other contributors' articles, submit news items and communicate through a well-developed messaging system, all this under the watchful eyes of administrators who decide what should be published and what should be returned to their authors or rejected.

SPIP is used by tens of thousands of Web sites, especially in France, where very well-known mainstream publications and government bodies like the Ministry of Foreign Affairs base all of their sites.

SPIP was first developed in French, mainly for a French public. At this stage, the system could be used by anyone to create and use French and non-French sites, but they had to understand French to be able to find their way around the newsroom as its interface was completely in French. Quickly, SPIP's qualities attracted the interest of

01

02

01 SPIP a true multilingual Content Management System.

02 SPIP's translations management makes it easy to display any translation of an article with one click.

03 The back office in SPIP is customizable in more than forty languages.

developers of non-French sites, mainly those developers interested in incorporating Arabic and Spanish. But those Arabic and Spanish sites were to be used by contributors who did not speak French. So the Arabic and Spanish developers had to go through all the text strings, which appear in the newsroom interface in the system, and translate them one by one until the Arabic and Spanish versions appeared as stand-alone distributions distinct from the original French system (this is what is known as "forking" in the open-source community).

This localization effort was limited to the interface of the SPIP newsroom only (although for the Arabic, the interface had to be redesigned to switch to the right-to-left direction) and did not extend to the page templates that come with the system or to the typographical engine inside it, which means that developers of Arabic or Spanish sites would have the same old task of designing the whole public area of their sites in terms of look and feel and typographic and directional control. (Figure 03)

As mentioned earlier, had the original SPIP developer community shown no interest in the work of these two developers, their contribution would have remained isolated and, very quickly, they would have given up. But the SPIP development team was so enthusiastic about this project that they decided to turn the system into a true multilingual platform in the sense that not only the newsroom interface would be displayed in any of the supported languages but that the system would support all of the typographic rules of those languages in the articles and news items that appear in the public area and would be open to any language.

There were two main reasons behind this decision: the first one was obvious, extending the user base to include non-French speaking users and the second, a more philosophical reason, was supporting whatever allows various cultures to express themselves on the internet.

In order to achieve such a task, the system had to be stripped of all the text strings (e.g., every bit of text that users see in the interface including messages of all kind, which were originally in French) that it contained, and these strings were stored in a separate file. They were replaced in the system by as many variables, each one pointing to a text string.

Then a specific application was developed that allowed the translator to pick any French string and translate it into any language and store it in a file specific for that language. We ended up with as many language files as there were languages (forty languages and counting), and each time the user selected a language from the menu in the interface the corresponding file was loaded and the whole interface changed to accommodate the selected language.

Not only the selected language controlled the direction of the interface, but it also controlled the date formats (in different languages and in short or long formats) and the typographic rules (space before a semicolon or a question mark in French, inverted commas, left and right, as quotation marks in English or right and left pointing angular quotation marks in Arabic, etc.).

The direction received a special treatment in SPIP because it was not sufficient to declare a page as left-to-right or right-to-left, as every block of text had to be processed to control the change of language in it and also to control the interaction between the interface language and the content language especially in the newsroom area (for instance, if we want to edit an Arabic text in a Greek interface). Of course, all of the necessary tools are available to the site developer to implement a good directional control; ready-made systems should be dealt with to spare the developer the burden of implementing it and concentrate on their design.

What is more, SPIP introduced an automated process to change design direction in the cascading style sheet (CSS) based on the language of the site: if the site's main language is Arabic for instance, the system checks if there is a cascading style sheet called xxx_rtl.css. If there is not, SPIP creates one on the fly from the existing xxx.css sheet and switches all the directions in it (left and right properties are switched) and the site's pages appear automatically in the right direction.

03

As for the design, SPIP makes it easy to manage multilingual sites especially when the languages and directions of pages require different image treatments (for example, managing two instances of a logo, one in Latin and one in Arabic, and displaying the proper one on the right page). (Figures 04, 05, 06)

In its endeavor to promote multilingual aspects of sites, SPIP went even further and introduced translation management. If the site should include translated articles in different languages, the system will link all the translations to the original article so that when this article is displayed on the public site, various links appear that lead to the various translations. This way, if the visitor reaches an article that they want to read in a particular language, this language is only one click away.

SPIP is living proof that given the resources available, it is perfectly possible to match Arabic-based Web site development and design with its Latin counterparts. It all depends on the will of developers rather than on the available technology, which is at hand's reach.

Having said that, one cannot deny that there are limits to this assumption. And those limits have to be dealt with before Arabic (and other non-Latin languages) and Latin sites design and develop and we end up with a two-tier internet.

There are a number of design and content control tools that are getting better and better as far as Western sites are concerned and lagging dramatically behind in Arabic and more generally right-to-left non-Latin development, even in multilingual (and multicultural) systems like SPIP. Here is not the place to discuss these tools extensively, but we can mention three of them as a matter of example:

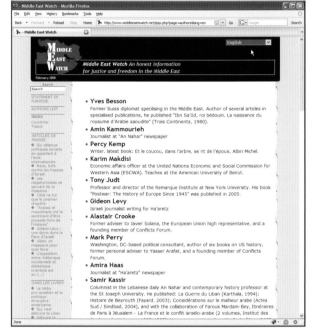

04

Clean URLs

Those who are used to browsing the Web know that a URL (Uniform Resource Locator) is basically the address of the page displayed in the browser and it appears in the address box on top of the page. Generally, the URL looks like: http://www.mysite.com/article15.html when the content displayed is an article numbered 15 in the system managing the site. This URL does not tell what the article is about, but a "clean URL" does. If the article is about holidays in the Seychelles, a clean URL will look like: http://www.mysite.com/holidays-in-the-seychelles, and quite a few Web users know this clean URL is better indexed in search engines than a generic one and, if the server hosting the site allows it, it is better to use clean URLs.

But the problem is that URLs do not accept non-basic ASCII characters (e.g., the first 128 characters of the ASCII table), which means that if the article's title is in Arabic (or in any characters not found in a Latin alphabet for that matter), it will not be supported and the URL of the corresponding page will be wrong. This problem has

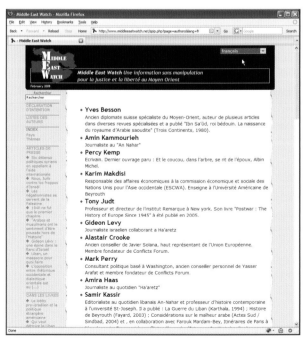

05

been solved for Latin languages by replacing the accented letters by non-accented equivalents and by transliterating non-Latin languages into Latin. But everyone knows that the Latin transliteration of Arabic is a pointless exercise as it yields completely wrong results, mainly because there are no vowel letters in Arabic. This means that Arabic will lag behind in clean URLs and Arabic sites will not profit from this feature that aims to improve search engine rankings.

SPIP is currently the only system that has tried to solve the problem with mixed results, as the Arabic string in the URL appears in hexa-decimal encoding and not in clear as in: site. com/%D9%85%D8%B1%D8%B4%D8%AD-%D8%AC%D8%AF%D9%8A%D8%AF-%D9%84%D8%B9%D9%84%D8%A7%D9%85%D8%A9.

Typographical images

The fonts displayed in Web sites are those that are installed in the visitor's user system, which means that the site developer should only use the fonts that they are sure are installed in all visitors' computers. But sometimes, the site designer chooses to display some texts in a nice font that is not typically found in the visitor's computer and he has a handy tool in some programming languages that, when the needed font is installed on the Web site server, can turn the text using that font into an image that appears on the site in exactly the chosen font. From a design point of view, this feature, which is used mainly for headlines, can provide very nice results but not in Arabic. As Arabic relies on linked characters that change shapes according to their place in the word, it is very difficult to produce an image from any text written in Arabic (or Farsi or Urdu), which means that the Arabic designer is deprived of this feature.

Spell check

With the number of Web sites based on textual content and collaborative work, spell check is becoming an essential tool in the back end (where the content is being created). Many CMSs now offer a spell-check feature to ensure that the texts published on the public pages are correct. But this feature lacks Arabic support, as Arabic spell check is more of an amateurish toy than a real productive tool.

Conclusion

For all of the progress that has been made through efforts like SPIP, examples like these three demonstrate how if nothing is done Arabic sites will fall behind Western sites in terms of features and design. It is up to the developers, as the tools to create these features are already available.

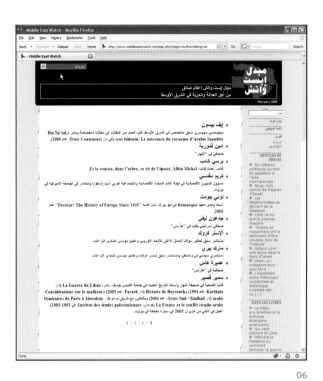

06

04, 05, 06 A multilingual site based on SPIP. The three languages are equally supported and the direction control is smooth.

Part II: Five Decades of Influencing Arabic Typography

Monotype Imaging

Monotype Imaging includes the following companies as part of its heritage: Monotype, Monotype Typography, Agfa Monotype, ITC and Linotype – making the company a leader in international typography from hot metal through the latest digital font technology. All of the companies are also active in the creation of Arabic typography, building on the foundation of early examples like Urdu 507, (Figure 02) Naskh 589 (Figure 03) and the famous typefaces Badr and Yakout designed by Walter Tracey and his team of experts.

In keeping with Monotype Imaging's objective of "staying ahead with the latest in typefaces and typographic technology," the company has launched Tanseek, a 21st century multilingual range of typefaces.

01

URDU 507

02

ARABIC NASKH ACCENTED 589

03

01 This hot-metal piece of type features the reversed image of the "dad" character.
02 First called Arabic 507 upon its creation in the late 1930s, Urdu 507 was the first Monotype Arabic typeface. Still available today, the typeface is called Jawhar.
03 In the late 1940s, Monotype created Naskh 589. Its popularity resulted in versions of this typeface, and Urdu 507, being converted to film in the 1960s for Monophoto, to Lasercomp in the 1970s and digitzed in the 1990s.

Tanseek

The notion that alphabets from different cultures can be unified is fanciful, but the idea is very seductive. After all, why should alphabets of entirely different letterforms and diverse heritages, that have existed independently for hundreds of years, now require some element of unification? A simple answer would be "air travel" and the second response would be "technology." Perhaps it is sufficient to stop there and not expand ad infinitum, as, in context, these two answers alone can justify both the precocious and indisputable purpose of a bilingual family of fonts, utilizing Arabic and Latin or other languages, letterforms.

Air travel from its inception during the 20th century has rapidly expanded knowledge and interests between cultures, and in their most communicable forms the thirst for knowledge and need for information can only be provided by the spoken or the written word. Additionally, of course, visual information can enhance these essential attributes, as photos, film and television have a supporting role to play. The spoken word can be recorded, but for 5,000 years at least, the spoken word did not have that advantage and the only method of memorizing words had been to write them down. Apart from oral dictation, writing quickly eclipsed the spoken word, as almost from the invention or introduction of writing, knowledge and information has been recorded in the majority of cases for the ephemeral and the mundane but also, much for our benefit, for religious, legal and historical inscription. In many cultures past and present the written word has been deemed as sacred, and additionally, so have the people who transcribed them. In ancient Egypt, Thoth was the god of writing and Ptah was the god of craftsmanship and technology. In Arab countries, Japan and China, scribes are still honored, if not revered, for their skills as calligraphers, and by extension, communicators of the written word.

All of the great number of languages that have developed for human enlightenment were, until the age of air travel, reasonably isolated from each other in the sense that only individuals or small groups traveled and crossed language barriers. It became necessary to read and learn a language even without traveling to that country, and also to comprehend the letterforms with which they were written. In this age, traveling to countries and continents where there is a different culture and language, and more essentially a different alphabet, is commonplace. One of the simplest ways of dealing with the situation where a common alphabet is used, in the majority of cases, the Latin alphabet of twenty-six letters, is to provide a translation, be it for an entry permit, travel brochure or even a menu. This is a fairly straightforward solution and often for aesthetic reasons and to provide

typographic harmony, the same style of typeface is used for both languages. Occasionally, different typefaces of the Latin alphabet are used in translation; this may be at the whim of the designer or possibly used as the lowest common denominator, so as to encourage the reader to subliminally relate to their own language more readily.

In a country where the alphabet used is different from that of the traveler, the situation of a visual typographic compatibility can sometimes be resolved harmoniously. Certain alphabets such as Greek and Cyrillic have not only a common or linked root to the Latin alphabet, but have also been adapted stylistically by modifying a basic type design, providing for balance and continuity. Even in circumstances where a common style typeface is available, it does not always follow that the typeface is used; the question of choice may be related to context and localized identity.

In the larger proportion of cases, for example, Arabic, Hindi, Chinese and Japanese, some of which are not alphabetical in origin, the stylistic development of the letterforms have evolved in a mechanical form that continues to reduce visual harmony. In essence, the mechanical technology that created the printed word has caused greater dissonance. The specific case of the relationship between Arabic and Latin alphabets is a good example, as until recently with the development of digital design and technology, mechanical control artificially dictated the appearance of the printed word as opposed to the source from which it came, the written word, from the art and skill of the calligrapher. The long and extended period of metal typesetting created physical boundaries that changed the form, natural relationship of the letterforms and the freedom of the design and typographic layout of Arabic text.

The methods of creating typefaces for printing from metal type were developed for the Latin alphabet. When other alphabets, such as Arabic, were cast using the same process, they had to conform to the established system – compromises and sacrifices had to be made. Metal type was cast on a physical body, a block of metal that was divided into units, known as points. Any particular size, from text sizes of 10 and 12 points, to display sizes of 48 point and larger provided the physical restriction and maximum height of the collective letters within a font of metal type. The deciding and dictating factor lay, as far as Latin typefaces were concerned, within the construction of the letterforms to their overall height, which ranges from the ascending and descending elements of the lowercase letters. A typeface that has long ascenders and descenders has to fit within the size of the body it is cast upon; and a typeface with short ascenders and decenders also occupies the same height. This leads to a variety of visual appearances where two typefaces are described as the same point size, but one of the typefaces

04

05

06

04 Nakheel, one of the world's largest privately-held property developers, used Tanseek for its Blue Communities (for Better Coastal Futures) trademarked Arabic logotype.
05 The Tanseek Blue Communities (for Better Coastal Futures) trademarked Arabic logotype in detail.
06 The opening image for MBC TV's channel Wanesa, which uses Tanseek.

is larger within the capitals and lowercase sizes generally, by reason of the variance of their extremities.

The method of assembling type into lines was equally controlled by the height, or point size, of the body of metal type. A typeface would be set in lines so a 48-point size could not physically be set at less than 48 point. When a typeface is set in lines which were directly below one another, it is described as "set solid" or, for example, 48 point on 48 point. A typeface could have the line spacing increased by the addition of metal widths placed between each line, so a 48-point body could accurately be described as 48 point on 54 point, when a thickness of metal measuring 6 points was introduced between the lines.

Apart from the total visual contrast between Arabic and Latin alphabets, there are also conflicts of construction. Latin fonts normally have two forms of the alphabet, the capitals and the lowercase, which contains extensions above and below the lowercase "x height." Latin letters stand independently of each other and usually there is one design representing each of the twenty-six letterforms for both capitals and lowercase. The majority of Latin fonts are designed, unless it is a script or it is meant to mimic handwriting, so that each letter is set and spaced apart from its fellows, and Latin fonts can be described as being of a vertical construction.

The contrast and conflict of construction within Arabic letterforms is exemplified as it is a single alphabet, there are no capitals, but there can be up to four forms of the same letter depending where they fall in a word. The individual Arabic letters in metal type also contain a calligraphic element – moreso than in Latin derivatives, where it has virtually disappeared – whereby Arabic letters are physically linked to each other by a continuous horizontal stroke within a word, which appears in the lower half of the letters. There are varying heights and depths of ascenders and descenders within an Arabic alphabet, with a far greater range than Latin, and up to eight diacritical, or accent, marks denoting vowel sounds, whose positions, depending upon their placement within a word, often exceed the height and depth of Arabic ascenders and descenders.

Visually, Arabic typesetting, where the letters are joined together with rising and falling extensions and diacriticals within the majority of words, has a fluid and horizontal aspect differing from the more controlled and inflexible Latin letterforms, and the style of typography dictated by those constraints. All of the accumulative variations in increased height and depth on the physical body of Arabic letterforms compared to Latin ones creates a situation where the Arabic is actually smaller. When Arabic text is set solid in lines of metal type alongside or in close proximity to a piece of Latin text, and when the eye is directly or peripherally aware of both sections, there is a visual discordination because of the

وراء كل
شركة ناجحة
فكرة تتجسد
في شعار
وسمة مميزة

قوة الفكرة

وراء كل شركة ناجحة فكرة. والفكرة القوية توحد
وتحدد التوجه الذي تسلكه الشركة وما تسعى إلى
تحقيقه. فكرة تهتدي بها الشركة تجارياً وتجعل
الأفراد يشعرون بالفخر والانتماء. وتتجسد هذه
الفكرة في شعار مميز يساعد المؤسسة على النمو
والتطور والازدهار.

وهذا الكتاب يعبر عن شعارنا وسمتنا المميزة.
ويشرح ما يجعل درة البحرين مشروعاً خاصاً وفريداً
من نوعه. ويلخص الإثارة التي نعد بها عملاءنا وما
ينبغي علينا جميعاً عمله لتحقيقها.

07 Corporate Edge. Durrat Al Bahrain's corporate identity and corporate
typeface relies on Tanseek.

difference in size and the controlled spacing between the lines of text. The Latin text is larger and the Arabic text has greater space between the lines. This has been described as "visual schizophrenia" when the eye jumps backward and forward attempting to create a textural balance that cannot be reconciled.

Apart from the inherent differences between Arabic and Latin letterforms and the adaptation for mechanical typesetting already mentioned – the variation in heights and depths of ascenders and descenders, the placement of diacriticals and the vertical connecting strokes in Arabic that create a strong visual rhythm, as opposed to the separate, horizontally unconnected Latin letterforms and the use primarily of one set of alphabetical letters for Arabic compared with two sets for Latin – there is also the overwhelming aspect of Arabic text reading from right to left, and Latin text reading from left to right.

All of the original variations of written Arabic as converted to printed Arabic via mechanical typesetting have been magnified or distorted by the process. During the 20th century the new technology of filmsetting and photosetting was introduced, and all the limitations and restrictions of metal technology were adopted wholesale for these new methods of setting text. Indeed, which now seems perverse in hindsight, the adaptation from metal to film and photo deliberately followed the metal measurements, point size systems and line spacing because the world of typesetting was controlled by a small number of manufacturers who initially ran both systems of typesetting side by side, until the economic advantages of film and photo setting gained inevitable supremacy. The major consideration for the manufacturers of typesetting systems was actually to retain the appearance of Arabic text from metal technology to film and photo technology. They strove mightily to achieve this and their concerns were mainly of a technical nature, where considerations of linking letters and letter spacing were addressed, using the same typefaces without modification to their design for a different process. This is probably the greatest criticism, at a time when a new technology gave an opportunity to redress the restrictions of an old technology, primarily with a reappraisal of the letterforms and typefaces themselves, and how they could take advantage of a release from physical boundaries, the consideration was to retain the visual status quo because the typesetting manufacturers controlled the range of Arabic typeface styles and their means of production.

One of the most pertinent developments for typeface design, both Arabic and Latin, came about in the latter half of the 20th century with the invention of the dry transfer process. This was led by Letraset, who manufactured sheets of "Instant Lettering" which allowed designers and typographers to form words and texts by releasing a letter from a retaining sheet.

Specifically, during this current period of digital development there have been many improvements to both Arabic and Latin type designs and systems, but in general, the question of a visual balance for bilingual use has not been addressed. In other bilingual combinations as previously mentioned, Greek and Latin and Cyrillic and Latin, where the adaptation of letterforms has been relatively straightforward to be able to achieve a successful visual similarity using Latin typeface designs as a base. The same methods cannot be applied for an Arabic and Latin visual relationship, as the inherent differences are too extreme. To achieve a compatibility and harmony for Arabic and Latin, typography would need a new approach.

The design of the bilingual typeface Tanseek began with research of the current applications of bilingual Arabic and Latin from all forms of media, but predominately Arabic magazines and journals. The results established that where Latin typefaces were used in conjunction with Arabic typefaces, the choices of a Latin style to accompany an Arabic style amounted in the majority to either Times Roman as a serif style or Helvetica as a sans serif style. The occasional choice of typefaces other than these were notable only by the lack of occurrence and could best be described as patchy, representing only single percentage figures in relation to Times Roman and Helvetica. One explanation perhaps for their constant use would be that they are system or free fonts, and as a consequence become automatic as a choice, and on a repeat basis. Additionally, from editorial or agency pressures, Arabic designers were encouraged to use these particular Latin fonts regardless of compatibility with Arabic, because they were ubiquitous for Latin text in general and as such were recognizable and familiar.

The contention for breaking this cycle with the design of the bilingual typeface Tanseek was rooted in the belief that a better solution could be made for Arabic text when Latin was being used as a supplementary font. To achieve a harmonious relationship between the two alphabets required compromises, and the first and most important of these was to establish a means where the overall heights and depths of each alphabet, Arabic and Latin, could be brought closer together. By a series of tests, it was seen that the Latin lowercase could be reduced slightly, but the essential change within the Arabic alphabet was for the central portion of the letters, equivalent visually to a Latin "x height," could be raised and increased to correspond with its Latin companion. This design decision also had the benefit, when used within lines of text, of creating a superior "typographic color" on the page. If anything, it slightly reversed the previous and established standard where the Arabic lines of text were openly spaced compared to the Latin, and if the lines of text were spaced identically the Latin text appeared slightly more open as their extensions did not

Arabic لاتينية

Arabic لاتينية

Arabic لاتينية

Arabic لاتينية

08 Sans Serif x-height

Latin & Arabic in harmony حروف لاتينية وعربية متناسقة

Arabic لاتينية

Arabic لاتينية

Arabic لاتينية

Arabic لاتينية

09 Serif x-height

08, 09 Naskh is the Arabic book-production calligraphic script that formed the nucleus of Arabic typography. It was used for plain text, whether in the form of delicate calligraphy or routine scribbling – but without exception adhering to the same strict morphographic rules that made it perfectly legible, facilitating the evolution of Naskh into type. It has become the ultimate challenge to the type design and font technology industries to reproduce a natural Naskh script. Tanseek does this, as the best type designs are those that attempt to give back to the reader the pleasure of functional elegance.

إذا أومأ الحب

إذا أومأ الحبّ إليكم فاتبعوه، وإن كان وعر المسالك. وإذا بسط عليكم جناحيه فاستسلموا له المنحدر. وإذا دعتكم مصغّوه وإن كان لصوته رخ المسالك وإن ضعف. أحضانكم كما بظم. وإن كان لصوته رخ الشمال بالبستان. وإذ حدّثكم صدّقوه وإن كان لصوته رخ الشمال بالبستان.

إذا أومأ الحبّ إليكم فاتبعوه، وإن كان وعر المسالك. وإذا بسط عليكم جناحيه فاستسلموا له المنحدر. وإذا دعتكم مصغّوه وإن كان لصوته رخ السنبل بالبستان. وإن حدّثكم صدّقوه، وإن كان لصوته رخ الشمال. سبيه المستور بين نواعمه. وإذا حدّثكم مصغّوه وإن كان لصوته رخ السنبل بالبستان، ومو كما بشت من عودكم، كذلك ينشت من أعالي أغصانكم وهكذا يرفق إلى أعالي أفنانكم. وبداء: أعناقكم الغضّة ينسّ في فيء الشمس.

إذا أومأ الحبّ إليكم فاتبعوه، وإن كان وعر
When love beckons to you, follow him

Arabic typefaces are not usually more than 2 weights (Black & White), whereas Latin fonts normally have at least 4 weights in a family. Until a few years ago there has been a development for 8 weights (Light, Medium, Medium italic, Bold, Bold condensed, Bold outline, Bold shadow & Bold inline) but in Arabic only and without any real Latin matching style. The Medium italic and outline, shadow and inline weights need special treatment to achieve the desired results due to the Arabic language being a linked language. Latin alphabets have capitals and Lower case, and the structure is balanced around the x-height. Arabic functions differently within its weights, without the benefit of a visible x height. This range has been designed for the

When love beckons

Arabic typefaces are not usually more than 2 weights (Black & White), whereas Latin fonts normally have at least 4 weights in a family. Until a few years ago there has been a development for 8 weights (Light, Medium, Medium Italic, Bold, Bold condensed, Bold shadow & Bold inline) but in Arabic only and without any real Latin matching style. The Medium italic and outline, shadow and inline weights need special treatment to achieve the desired results due to the Arabic language being a linked language. Latin alphabets have capitals and lower case, and the structure is balanced around the x-height. Arabic functions differently within its weights, without the benefit of a visible x height. This range has been designed for the first time so that Latin and Arabic match perfectly in style, weight, balance and legibility. Arabic typefaces are not usually more than 2 weights (Black & White), whereas Latin fonts normally have at least 4 weights in a family. Until a few years ago there has been a development for 8 weights (Light, Medium, Medium Italic, Bold, Bold condensed, Bold shadow & Bold inline) but in Arabic only and without any real Latin matching style. The Medium italic and outline, shadow and inline weights need special treatment to achieve the desired results due to the Arabic language being a linked language. Latin alphabets have capitals and lower case, and the structure is balanced around the x-height. Arabic functions differently within its weights, without the benefit of a visible x height. This range has been designed for the first time so that Latin and Arabic match perfectly in style, balance and legibility.

10, 11 In the past, Arabic typefaces have not usually contained more than 2 weights, whereas Latin fonts normally have at least four weights in a family. Today, it is common for font families to contain eight weights (Light, Medium, Medium italic, Bold, Bold condensed, Bold outline, Bold shadow & Bold inline). Until the creation of Tanseek, there has not been a way to match these Arabic weights with their Latin counterparts. Tanseek has been designed so that Latin and Arabic match perfectly in style, weight, balance and legibility.

range to the same amount as the Arabic text. But in essence, this was preferable.

Fortunately, the Arabic and Latin styles of typeface design divide into two main categories: Traditional and Modern for Arabic and Roman and sans serif for Latin. These two sets of alphabets relate stylistically, Traditional with Roman and Modern with sans serif. So the challenge for creating a greater harmony between the variant letter structures required taking into account their inherent differences and at the same time accepting each alphabet had dependable and established letterforms.

Arabic type design has, to some extent, a textural and a visual anomaly between its two defined categories, Traditional and Modern. Traditional Arabic typefaces have not digressed greatly from their calligraphic roots, written with a broad nib wooden pen that creates freehand curves and extremes of thick and thin within its structures. Modern Arabic typefaces developed during the 20th century with either a monolinial or bilinial emphasis that, on occasion, foregoes the emphatic horizontal connections. Latin styles have evolved from Roman to sans serif, but Roman typefaces long ago lost their calligraphic influences and although Roman typefaces do have a vestigial acknowledgement to their origins in calligraphy in the form of serifs and occasional stress of the pen stroke within the letters, a consequence of the general lack of freehand influence allows the Latin Roman and the Latin sans serif to be more constructionally related than Arabic Traditional and Arabic Modern. Uniting the Arabic and Latin styles for the family of Tanseek drew upon the strengths and examples of both alphabet forms, as the Latin Roman was influenced by the Arabic Traditional, having a more than usual calligraphic emphasis and a softness of curve within the lowercase letters, so creating a bond between the two formal alphabets.

The structure of the sans serif took as much from the Roman as practical for a visual monoline style, and does consciously have humanist characteristics for a sans serif, as opposed to 20th-century Industrial influences. As far as possible, Arabic Modern has adopted elements from the Latin sans serif inasmuch as weight, balance and continuity. All of these elements have given a synchronicity to the Tanseek family, which is unique.

A guiding principle for typeface design is legibility. That said, there are varying degrees of legibility, depending to an extent on what is to be read and the circumstances of reading it. Print on paper may still be in the majority, but typefaces are used for signage, both static and mobile, for television credits and captions which in many cases scroll across the screen, and on the internet which is probably the largest category for information text, and mobile or cell phones, which have become increasingly sophisticated typographically. To relate to all these conditions and more, a bilingual typeface requires a series or family of weights and styles. Tanseek has four weights of Traditional and Roman, and four weights of Modern and Sanserif and they are designed to be harmoniously related and work ideally in combination. They are equally effective using a single weight structure, such as Traditional Medium and Roman Medium as they are in other combinations, such as Sanserif Light and Traditional Extra Bold, because Tanseek has been designed as the first bilingual Arabic and Latin typeface that can be utilized in this way. The nature and characterization of letterforms, both Arabic and Latin, have progressed to reflect, encompass and enhance modern visual communication. In the case of Tanseek, the design has taken a step further to facilitate the growing demand for cultural exchange by providing a typographic solution that is visually sympathetic and pleasing.

Compugraphic

No discussion about the impact of technology on Arabic typography would be complete without considering the Compugraphic, or "CG," EditWriter 7800 Arabic photocomposer, first sold circa 1979. Originally built without provisions for setting complex languages, the EditWriter (Figure 12) was a composing station with attached photo unit. The EditWriter's internal multiprocessor was possibly more advanced than the first models of IBM personal computers.

The composing station featured a keyboard, display and floppy disk drive. The days of punched paper tape were gone. The photo unit contained two removable filmstrips attached to a rotating drum; a lens turret changed point sizes. Filmstrips had four typefaces each for roman, bold, italic and bold italic weights. (Figure 13) The drum rotated at high speed. As the desired character on a filmstrip passed the lens, the photo unit "flashed," creating an image on photographic paper or film at the selected point size.

Complexities of developing an EditWriter for Arabic were clear from the outset: the large number of character shapes, high ascenders and low descenders making diacritic placement a problem, text justification by kashida as well as word spacing, and Western language words mixed with Arabic text on the same line.

Additionally, research found Arabic language newspapers predominantly used a different, simplified form of typography, where one character shared the initial and medial shapes and one character shared isolated and final shapes. This "simplified Arabic" was a holdover from older generations of pre-press equipment. If the EditWriter 7800 was to be a viable product for the newspaper market, it had to support both simplified and traditional Arabic typography. This led Compugraphic to expand the capability of the 7800 software and design complementary Simplified Arabic Light and Simplified Arabic Bold typefaces.

It's an unwritten rule of computer software that once you introduce a popular feature do not take it away. Simplified Arabic Light and Simplified Arabic Bold are classic examples. These original Compugraphic typefaces are included in office and publishing applications today. However, the immediate emphasis of the 7800 development was traditional Arabic script.

One of the first issues Compugraphic addressed was accommodating all the Arabic letterforms, diacritics, ligatures, digits, punctuation, symbols and other characters necessary for a Naskh-style typeface. The designers found a novel solution. Rather than follow the conventional arrangement of four weights on a filmstrip, Traditional Arabic was distributed across sequential tracks of two paired filmstrips: Traditional Arabic regular on track

one of each filmstrip and Traditional Arabic bold on track two of each filmstrip, allowing Compugraphic to double the number of characters in a typeface. The remaining tracks were available for other typefaces, including Western languages to allow language mixing. The use of sequentially paired tracks also maximized performance of the photo unit, providing faster setting speed, compared to using adjacent tracks on the same filmstrip.

At the same time, the issue of diacritic placement had to be resolved. The photo unit flashed along a straight line, setting type left-to-right and right-to-left, not up and down. Unlike a Western language based on vertical construction relative to its x-height, the 7800 had to place diacritics above and below Arabic shapes with large variations of ascender heights and descender depths. Compugraphic found a solution by creating two sets of diacritic designs at different heights. Each typeface had a set of "low" and "high" diacritics. The low set was closer to the baseline and the high set further from the baseline.

A similar set of "high" and "low" diacritics was created below the baseline to accommodate variations in descender depths. The 7800 software selected the appropriate height depending on the letterform. The solution produced a reasonably aesthetic result given the technology available at the time, but not visually optimal.

Ascender and descender sizes created a second problem relative to the em-square. Low descenders dropped below the bottom of the em-square and high ascenders rose above the top of the em-square, resulting in offending letterforms that would be cropped when a character was flashed. Such unacceptable conditions caused Compugraphic to establish a higher baseline for Arabic typefaces, creating an adverse side effect. Arabic text did not scale proportionally to Western language text, as discussed in the Tanseek section.

At the time of the 7800's introduction, Compugraphic offered Traditional Arabic Light and Traditional Arabic Bold in classic Naskh style, plus Simplified Arabic Light and Simplified Arabic Bold. The library grew to include typestyles such as Arabic News, Kufi, Lakhdar and Ousbouth, and additional weights such as extra bold and outline.

Unknown to the 7800 designers, the concept of low and high diacritics and the raised baseline would be carried forward for twenty plus years through no less than six products from three different suppliers, including Arabic editions of Microsoft Windows 3.1 and Microsoft Windows 95. It was not until the development of OpenType by Adobe Systems and Microsoft Corporation that the technical limitations on diacritic placement would be overcome.

Compugraphic eventually became Agfa Compugraphic. What was Compugraphic Type Division is today Monotype Imaging.

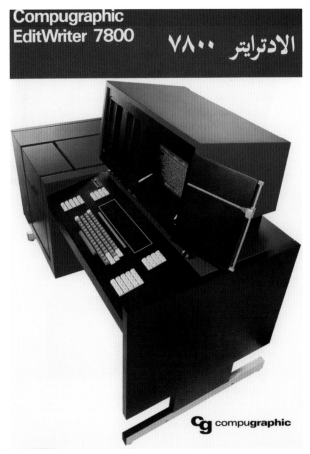

12

13

12 Compugraphic EditWriter 7800
13 EditWriterFilmstrip

Glyph Systems

In 1988, the United States was the hub of a worldwide software market, barely out of its infancy. American companies were producing PC applications for English and European languages, ignoring most all non-Western languages. This presented a void in the market waiting to be filled. Al-Nashir Al-Maktabi was created for the Apple Macintosh by the British company Diwan. It was the only viable Arabic product for desktop publishing. (A version for IBM-compatible personal computers was not available until 1994.) Macintosh computers typically sold for two to three times the price of PCs in the Middle East and were purchased largely because of Al-Nashir Al-Maktabi.

Two former Compugraphic colleagues, Gabriel Habis and Steven Reef, recognized the market opportunity and founded Glyph Systems. The first product Glyph set out to develop was an Arabic-enabled version of Ventura Publisher, the most popular desktop publishing software for PCs. Ventura Publisher ran on GEM, a graphical user interface for MS-DOS, that predated Microsoft Windows. As simple as it may seem, the lack of Arabic fonts for the GEM and MS-DOS environment proved to be a substantial technical barrier. Glyph turned to the source Habis and Reef knew best, the Compugraphic Type Division, to license CG's Type Director product and extensive library of typefaces.

Type Director was a high-quality font generation program for printers, screens and application software. It used outline typefaces in Compugraphic Intellifont format to create bitmap fonts ranging from 4-point to 200-point in ½-point increments. Glyph added new capabilities and features for Arabic and other non-Western languages and re-branded the product "Typographer," the first LaserJet font generator for Arabic MS-DOS applications. Although the original goal was providing fonts for Arabic-enabled Ventura Publisher, the significance of Typographer led it to becoming Glyph's first product. Introduced to the market in 1989, Typographer launched Glyph into the non-Western languages font business.

In April of 1990, Glyph announced Arabic-enabled Ventura Publisher, bringing to market the first Arabic desktop publishing product for PCs. It was sold as a bundled package with Typographer and eleven Compugraphic typefaces. (Figure 14) is a sample of 300 DPI laser printer output.

Eleven years after the EditWriter 7800 was introduced, Arabic typography was available as a mass-market product for a fraction of the price and no special equipment required. Predictably, Arabic-enabled Ventura continued to experience the same diacritic placement problem, and size difference in text scaling, as the EditWriter 7800.

Glyph Systems divested its Arabic Ventura product to Layout Ltd, a relatively new company founded by Habis and Joseph Abi Raad, in Cyprus. Layout then developed a well-received Arabic extension to Quark XPress, which has been updated over the years and marketed to this day. Glyph expanded upon Typographer and advanced to production of Arabic fonts in TrueType and PostScript formats, as well as other non-Western languages. In the same timeframe, Microsoft Corporation contacted Glyph about Arabic font development.

The Arabic edition of Microsoft Windows 3.1, commonly referred to as "Arabic Windows 3.1," included Compugraphic Traditional Arabic and Simplified Arabic fonts. Limitations on diacritic placement, and scaling mixed Arabic and Latin text, were still present, historical remnants of the EditWriter 7800.

Soon after Microsoft brought Arabic Windows 3.1 to market, Glyph Systems offered the largest library of Arabic Windows fonts in the world. This accomplishment was made possible by licensing Boutros typefaces from International Typeface Corporation (now part of Monotype Imaging), and the Compugraphic Arabic typefaces, as well as Glyph's own designs.

Microsoft continued Traditional Arabic and Simplified Arabic to the Arabic edition of Microsoft Windows 95, commonly known as "Arabic Windows 95," one of the first versions of Microsoft Windows to use TrueType Open smart font technology, the predecessor to OpenType. This new technology laid the groundwork to finally solving Arabic typography problems dating back to the EditWriter 7800. For the first time, typeface designers had the flexibility to include typography information in the fonts, exercising a level of control not previously possible. No longer was font information hard coded internally in Microsoft Windows. Adding to that, Arabic Windows 95 TrueType fonts were encoded in Unicode, breaking the barrier of 254 character font pages. Paul Nelson's Arabic Computing Solutions, under contract to Glyph Systems, coded the True Type Open font tables for Arabic.

It would be several more years before technology to vertically position diacritics was implemented in a later version of OpenType and development tools became available.

ARABIC IN VENTURA PUBLISHER®

رَحْلَةُ كُريستوف كولومْبُس

قَرَّرَ كولومْبُس القيامَ بِرَحْلَةٍ كُبْرى، لِيُثْبِتَ نَظَرِيَّتَهُ بِأَنَّ الأَرْضَ كَرَوِيَّة. عَرَضَ كولومْبُسُ الْمَشرُوعَ على مَلِكِ اسْبانيا فِرْدِينان وَزَوْجَتِه ايزابيل، فأَعْجَبُهُما الْمَشرُوع. سَأَلَهُ الْمَلِكُ: ما طَلَبُكَ؟ قالَ كولومْبُس: اطْلُبُ ثَلاثَ سُفُن مُحَمَّلَةٍ بالْمُؤن. فَوافَقَ الْمَلِكُ وَقالَ له : إذا نَجَحْتَ سَأُكافِئُكَ.

قَرَّرَ كولومْبُسُ القيامَ بِرَحْلَةٍ كُبْرى، لِيُثْبِتَ نَظَرِيَّتَهُ بِأَنَّ الأَرْضَ كَرَوِيَّة. عَرَضَ كولومْبُسُ الْمَشرُوعَ على مَلِكِ إسْبانيا فِرْدِينان وَزَوْجَتِهِ ايزابيل، فأَعْجَبُهُما الْمَشرُوعُ. سَأَلَهُ الْمَلِكُ: ما طَلَبُكَ؟ قالَ كولومْبُس: أَطْلُبُ ثَلاثَ سُفُن مُحَمَّلَةٍ بالْمُؤن. فَوافَقَ الْمَلِكُ وَقالَ لَه : إذا نَجَحْتَ سَأُكافِئُكَ.

حـركة مقبولـة في جميع المرافىء اللبنانيـة.

الامطار الغزيرة التي هطلت في شهر كانون الاول الماضي، والاعياد التي مرت خلاله، ساهمت في تسجيل نشاط ملموس في معظم المرافىء اللبنانية. نتيجة لانتظار البواخر الطقس الجيد لتفريغ حمولاتها ولازدياد كميات البضائع المستوردة التي تكون عادة اكبر من كميات البضائع التي تفرغ في الاشهر الباقية من كل عام. لذلك استقبلت مرافىء بيروت وطرابلس وصيدا وصور وسلعاتا والاوزاعي وخلده والجيه عددا كبيرا من البواخر من مختلف الانواع والاحجام المحملة بالكونتينرز والبضائع العادية، وخاصة الماكولات والمساعدات الغذائية والحديد والاخشاب والسيارات المستعملة.

وقد انعشت هذه الحركة معظم الوكالات البحرية التي كان البعض منها يعاني نقصا في ارداته بسبب تقلص الحركة في الاونة الاخيرة حتى ان عددا اخر منها بقي عدة اشهر دون ان يستقبل اية باخرة.

Ventura Publisher is a registered trademark of Ventura Software, Inc.

300 DPI Laser Printer Output from the Arabic version of Ventura Publisher
(Courtesy of Layout Ltd.)

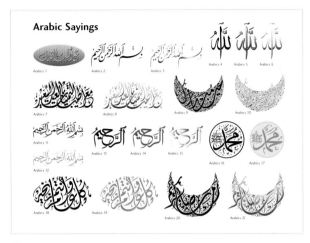

15

16

Letraset

Since its inception in 1958 Letraset has been synonymous with graphic design. Prior to the company's invention of dry-transfer lettering, designers had been frustrated by the limited choice of typefaces available to them in hot metal and the high cost of new phototypesetting systems, which had followed the offset revolution.

Demand for the technology reached across the globe and by 1976 the company was prepared to launch its first Arabic products, which were based on the traditional Naskh and Thuluth calligraphic styles. By that time, however, Arab designers had already begun to develop and use new Arabic typefaces, whether for magazines and newspapers or for multinational marketing and advertising campaigns.

Mourad and Arlette Boutros led the way for Letraset to introduce new Arabic typefaces to the world, including ones with a range of weights, Arabic sayings and dry-transfer sheets that reflected the differences in regional Arabic dialects.

Always keen to find the best in contemporary type design from all over the world for its Letragraphica series, Letraset held competitions for type designers working with all languages. One such contest was held solely for Arabic type and the result was a major extension of the company's Arabic range.

The 1980s saw the end of dry-transfer as digital type became the preferred industry medium. Letraset converted its library, including the new Arabic ranges, into PostType and Truetype formats and began selling the library through its extensive global network originally on individual floppy disk and then on CD. Today most sales are made as online digital downloads providing the user with the same immediacy as was enjoyed in the dry-transfer days.

15, 16 Arabic sayings and ornaments
17 Boutros Advertisers Naskh Medium, the most used and pirated typeface DTP based on the calligrapher ruler's style.

Letraset™ instant lettering®

4134

Advertisers Naskh Medium — Mourad Boutros

النسخ الاعلاني . متوسط — مراد بطرس

لتراست

١٤ ملم . 14mm

4134

The Boutros Group

Boutros International, headed by Mourad and Arlette Boutros, has led the field of Arabic creativity, typography, calligraphy and design for more than forty years.

If you've ever been to the Middle East, caught a glimpse of an Arabic newspaper or seen a highly recognizable Western brand's logo converted to Arabic, then the chances are that you've seen Boutros's work. Since 1966, Boutros International has focused on meeting the latest technological requirements and the creative needs of the Arabic-speaking world. Its designers and technical experts are consistently at the forefront of new developments. Working globally, projects have ranged from the creation of Arabic typeface collections for internationally renowned software and design houses to corporate Arabic logotypes and private commissions. Successful results are founded on balancing strategic thinking with generating contemporary Arabic designs and typefaces.

Mourad and Arlette Boutros first worked with Letraset in 1976, developing, for the first time ever, a four weights Arabic range of typefaces. In 1986 this range was also developed to work with Apple System 7.0 based on Apple's needs at the time to serve the graphic industry with a desktop publishing calligraphy based range of typefaces in TrueType format. Keeping ahead of the times with the latest technology and market demands, in 1989 Boutros introduced the eight weights versions of select ranges of Arabic typefaces in collaboration with Glyph systems-USA. (Figure 18)

Boutros has introduced the newly released Tanseek (Please refer to page 35) ranges of Arabic-Latin typefaces in harmony with collaboration with the well-known Latin typography experts Dave Farey and Richard Dawson of Panache typography. Now these ranges are being extended into more weights and wider languages to become a range of global fonts due to its uniqueness and quick success.

شـركـة بطرس الدولية لتصميم

Light

قامت شركة بطرس الدولية للإستشارات والتصاميم بابتكار مجموعة من الخطوط والزخارف العربية، أخذة في عين الاعتبار امكان تكيفها لتستخدم من قبل أجهزة التنضيد التصويرية والإلكترونية، وتلك العاملة بالليزر، لهدف استعمالها في تنضيد النصوص، من كتب ومجلات عربية ومن أهم التطورات التي شهدتها صناعة الخط العربي على أجهزة الكمبيوتر الشخصية، دخول الخط العربي عالم النشر المكتبي والصحفي، ومحاولة التطور مع التكنولوجيا الغربية، بكل ما فيها من تعقيدات، ومراعاة المحافظة على تقاليد الخط العربي. إن القسم الأكبر من الشركات العالمية يتعامل مع منطقة الشرق الأوسط بمنطق ومفهوم تجاريين فقط، وإذا أخذنا قسم الشرق الأوسط/إفريقيا الذي يتبع عادة للقسم الدولي في هذه الشركات، فإنه لا يمثل أكثر من ٣ إلى ٥ ٪ من مجموع مبيعات من المصنعة لأجهزة الكمبيوتر الشخصية

Medium

شـركـة بطرس الدولية لتصميم

Medium Italic

شـركـة بطرس الدولية لتصميم

Bold

شـركـة بطرس الدولية لتصميم

Bold Condensed

شـركـة بطرس الدولية لتصميم

Outline

شـركـة بطرس الدولية لتصميم

Shadow

شـركـة بطرس الدولية لتصميم

Inline

18 Boutros Farasha eight weights

Grapheast

Established in 1996 in Dubai Grapheast comprises three distinct divisions that cater to Middle Eastern markets: Distribution, Image, Solution – delivering Adobe, Corel, FileMaker, Extensis, Maxon, Pantone and ORIS, among other leading brands, across various markets in the region. In 2003, Grapheast became Adobe's sole distributor for the Middle East.

Grapheast had also developed arPix Professional, an application developed for the Arab user who wants to type Arabic in applications that do not support the Arabic language. (Figures 19, 20)

URW

Started in 1972, URW++ has specialized in developing and marketing innovative font and software products for an array of languages, including Arabic, keeping up with the multinational and multilingual demands of the global market. As well as the impressive URW++ font library, the company is also the creator of IKARUS, a font design and production software tool launched in 1975. Over the course of the next decade, major typeface manufacturers like Linotype and Letraset licensed the IKARUS software in order to create new typefaces.

IKARUS was the first software that permitted a typeface designer to create digital outline fonts, enhancing the process of converting non-Latin, calligraphy-based alphabets into digital formats without compromising the original letterforms.

19

20

19, 20 *Double Faced*, Grapheast's new type book, showcasing the Khotout collection and including Boutros International Arabic Fonts.

Diwan (Apple), Quick Draw

Since 1982 Diwan has been producing an Arabic system for the Apple II, which grew to include a word processor, some simple applications and an Arabic translation of the built-in BASIC programming language. Then, in 1984, along came the Apple Macintosh. From 1985 Apple had the intention to make the Macintosh available for Arabic and Diwan worked with the Apple developers who created the original Arabic system for the Mac. The ideas developed then did not change significantly until Apple switched entirely to Unicode support in Mac OS X.

The two top people at Apple Paris in charge of the Arabic Mac were Hesham Abuelata and Gilles Mouchonnet. The first Arabic system was Version 3 running on the the Macintosh Plus. It shipped with four Arabic fonts that were produced by Diwan and one that was made by Apple.

Nadeem was named after Gilles Mouchonnet's son. The main design principle was to match the popular Yaqut font from Linotype but with important differences: the font needed to be look good on the LaserWriter – Apple's 300dpi laser printer – at small sizes. The font was designed to have straight joins and straight alef's. The proportions and thicknesses of the letters were carefully chosen, again to look good on the printer.

Geeza was a larger version of Nadeem for user interface purposes (as the default "application" font) – to look comparable in size to Times.

Apple wanted a "bold" font so Baghdad was created as a different style with a bolder look.

Kufi: its full name was Kufi Standard GK. GK were the initials of Ghassan Kubba, the Diwan employee who created it. It was also created to match existing styles.

Qahira was the system font created by Apple – a bitmap only font that was made to look OK when the font was greyed out. In those days a font was greyed by masking its characters with a chessboard pattern.

The Arabic Macintosh was a very important milestone for Arabic on computers. The lessons learned then influenced how Arabic was to be supported by the Unicode standard, which now influences the whole computer industry.

20 Diwan Standard-1

21 Diwan Calligraphic-1

Microsoft

What Is Smart Font Technology?

Smart font technology can be defined as font formats that allow the type designer to specify additional information about the way glyphs are used in the font. This allows the traditional "one character equals one glyph in the font" to be rendered obsolete. It also makes it possible for multiple glyphs to represent a single character (known as contextual or alternate forms) or a single glyph to represent a group of characters (known as ligatures).

Because there is intelligence built into smart fonts, they are very useful for rendering complex script languages and better quality typography for any language.

The smart font technologies in use today are Apple's AAT (Apple Advance Typography), the Summer Institute of Linguistic's Graphite and OpenType which is co-managed by Microsoft and Adobe and now an ISO standard. Each of these three has their benefits and detractors that font designers and application programmers must consider when creating and using fonts for that particular technology.

There are two approaches to providing typographic support through smart fonts. AAT and Graphite require the font developer to put specific language handling logic in each of the fonts. In contrast, OpenType requires the common language handling to be dealt with outside of the font while keeping typographic control inside of the font. Microsoft places the language logic in the Uniscribe engine. From my perspective this allows OpenType font developers to focus more on creating good fonts and less on the language handling logic required for the font to work.

For this discussion I will use OpenType as the framework to illustrate how smart font technology provides new possibilities to once again improve the level of typography to that which was possible before technology limitations snuffed the life from quality typography.

OpenType and Its History

Prior to Windows 95, Microsoft supported Arabic in Windows 3.1 and Windows 3.11 by using fonts that were encoded by code page. There were two font pages defined: Simplified Arabic and Traditional Arabic. There was an additional font page defined for Persian support. Each font page allowed for 255 characters to be used for the font. The use of the Arabic font pages required a hard-coded shaping engine for Arabic that was not able to expand to support other Arabic script languages.

The TrueType Open technology was architected by Microsoft after Apple declined licensing the Apple GX smart font technology (predecessor of Apple's AAT technology). The implementation of the Arabic Windows 95 font supported the isolated ("isol"), initial ("init"), medial ("medi"), final ("fina"), and ligature ("liga") forms. Differentiation in mark position was based on substituting glyphs that were positioned at two different levels. An assumption for the mark positioning was that the marks should always be placed on the trailing edge of the Arabic glyphs.

In August 1997, Paul Nelson started working at Microsoft to enable Arabic, Hebrew and Thai support in Internet Explorer. As a result of his previous connection with the Microsoft Typography team and his involvement in creating TrueType Open fonts, Nelson began doing some side work to begin the process of helping improve the Uniscribe OpenType engine, which was being worked on by Andrei Burago. The initial work led to an improvement in Arabic fonts by using glyph positioning for harakat. The move to support harakat location through glyph positioning also enabled the use of harakat on ligatures that was not possible with the TrueType Open engine. These changes were visible in Office 2000 and Windows XP.

At this time the initial cursive attachment work was done to allow the support of calligraphic font styles, like Nastaliq. As a result of conversations with Nastaliq style typography experts Nelson reached a conclusion that cursive attachment needed to be processed from the end to the front of the connected pieces. This led to changes in the OpenType shaping engine that would allow for reverse processing to support cursive attachment.

The Arabic Typesetting font that Microsoft released with Windows Vista began as an experiment to push the calligraphic limits that could be achieved with a computer font. This experiment was inspired by conversations with Thomas Milo about "proper" Arabic typography. In the initial version of the font, Nelson began to create some basic shapes and began adding various glyphs based on Arabic calligraphy rules he was learning. One of these rules was involving the "tooth" characters.

Other items that were developed and validated for support in Arabic OpenType fonts were a push to support all Arabic script languages in as many type styles as were used for the local language. As Nelson worked on the prototype of the Arabic Typesetting font he sat with a trained Arabic calligrapher to get lessons on how a calligrapher would write the characters using the reed pen.

A common issue with many fonts is the horizontal connection between characters being longer than if hand written. The calligrapher came up with a clever approach to designing connection points that allowed for the natural flow of the pen so glyphs could connect more naturally and text would be more compressed. Additionally, the design of the Arabic Typesetting font takes advantage of cursive positioning to enable the font to have more of the natural slant experienced when reading hand-written text.

Whether the support is for a particular Arabic script

writing style or special purpose, OpenType has demonstrated the ability to provide Arabic font designers a rich infrastructure on which to create type that is less bound by technical limitations.

What is needed now are font developers to develop Arabic OpenType fonts that use the extent of OpenType to determine what capabilities are currently not possible with OpenType so the technology can be improved so it is not the bottleneck to great type.

Consider the Arabic calligrapher (*khatat*) who sits down with a piece of paper, reed and ink. He is aware of the text that will be written, what size, what style, etc. As he strokes his pen across the paper he is making constant decisions and changes to decisions based on what has been done and what remains to be completed. The instantaneous judgment to elongate a character, add some space between characters, or put a ligature in place to compress the text or leave out the ligature to fill more space happens without conscious thought.

Unlike the *khatat*, the Arabic font designer must consider what he or she will design and all of the capabilities that should be present in the font to make the desired design. Each choice must be well thought out to enable the achievement of the end goal – a font that is aesthetically pleasing and useful.

Like the *khatat*, the Arabic font designer is bringing art to the page.

Arabic Font Design Issues

Connecting glyphs
Arabic is a connecting script. As such, the font designer must take into consideration the impact of rendering the glyphs that should appear to connect. Font outlines are scaled to render at various sizes. The process of applying mathematic formulas leads to rounding at various stages of the rendering process. Thus, it is possible that overlaps will render as gaps in certain situations.

To counteract mathematic rendering, it is important for the font designer to provide a 70-unit overlap in the connection location when the font designer is developing using a 2048 EM square value. This amount of overlap will ensure that there will never be gaps caused by rounding errors during rendering operations.

Ligatures
With the abilities of OpenType to provide rich typographic forms, the font designer must consider how many ligatures are sufficient. Some Arabic Type styles,

like Naskh or Thulth, can have many special forms when drawn by hand. The font designer should consider the purpose of the font he is designing and decide how many ligatures are really necessary for good typography with the font face that is being developed.

Mark positioning
The positioning of *harakat* above and below characters should be treated as an integral part of font design. It is true that *harakat* are often left out of the text written in Arabic script, and it may be tempting for a font designer to put off the design of the *harakat* until the end, or to create them as an afterthought or necessary task before finishing the font.

However, the style of the *harakat* should complement the font design as an integral accessory to assist in making the reading experience as good as possible. Pasting the *harakat* from a font of a different design will cause the type design to have conflict and could be awkward to read.

In some font designs it might be acceptable to place the *harakat* on a single level above or below the baseline. Other designs it may be possible to have the *harakat* and two levels. A good quality Naskh, Thulth or other traditional style may require the *harakat* to be placed vertically above or below each individual glyph to have the most beauty in presentation.

It is reasonable to assume that because the eye is traveling from right to left as one is reading the text, the horizontal placement of the harakat should be to the left (trailing) side of the vertical center. This will allow the reader to see the base letter and then understand the vowel that should be pronounced. (This is only true for inexperienced, hesitant beginners. In high-speed routine reading, complete images are processed as if they were logographs rather than individual letters and *harakat*. On the internet, examples circulate of texts that consist of words with only stable initial and final letters, the internal ones being randomly rearranged. These texts are perfectly legible without loss of speed.) Some fonts from the past aligned the *harakat* on the trailing edge due to technology limitations. However, aligning the *harakat* on the trailing edge of the base glyphs may be accepted by many.

What Language(s) to Support
The Arabic script as defined in Unicode can support all Arabic script languages from Morocco to Malaysia. When possible, Arabic font designers should consider including support for all languages that use the Arabic script. In some fonts made by designers in Pakistan, we have seen wonderful fonts that support Urdu but do not support a number of languages in their own country, let alone some basic Arabic characters that are not used in Urdu.

When a font designer makes a font that supports the entire Unicode character repertoire they add a significant

amount of work to their task. However, they open the possibilities of their font being used for a much wider set of users that they might not have considered in the past.

In Unicode version 5.0 there are 268 characters encoded for Arabic script languages that require around 700 glyphs to form all required shapes and ligatures. While most of the base shapes can be shared, some attention to making all of the forms is required. A font that supports typographic ligatures and other alternative glyph shapes could easily arrive at over 2,000 glyphs, depending on complexity of the design.

Support For the Qur'an
Many people desire to have Arabic fonts that are able to support at least quotations from the Qur'an. The process of getting a font approved for printing the Qur'an is very difficult as the people who ensure the quality of type that is used for printing the Qur'an insist that it meets all of the typographic and calligraphic conventions required for printing of the Muslim holy book. Owing to this fact, many font producers will choose to create fonts that allow the Qur'an quotations to be rendered well, but will never claim to support the typographic rules necessary to print the Qur'an.

22

23

22 Arabic Typesetting font with contextual tooth forms.
23 Scheherazade OpenType font from SIL Software. Scheherazade, named after the heroine of the classic Arabian Nights tale, is designed in a similar style to traditional typefaces such as Monotype Naskh, extended to cover the full Unicode Arabic repertoire.

WinSoft & DecoType

Among those most involved with the technological and code-writing aspects of Arabic typography, WinSoft is considered the leader of the pack. When the Macintosh from Apple computers arrived in 1984, a standard software available on all drives was MacWrite, which was based on a set of Latin typographic fonts. A few years later, Apple was prepared to launch their brand in Arabic-speaking markets, using a select set of Arabic fonts (Nadeem, Baghdad, Kufi and Geeza). There was a major problem, however, because these computers were incapable of running any word-processing programs with non-Latin typography. MacWrite could not handle Arabic fonts and texts. In the wake of the need for computers to be able to support Arabic, WinSoft developed, in 1987, WinText, a platform that permitted the digitization of Arabic for use on computers. All Apple computers distributed in Arabic-speaking markets were loaded with WinText as standard software, using the same four Arabic fonts that Apple had already licensed. WinText can be considered the base foundation for Arabic typography usage on computers, and for more than a decade, it was the best option available for people who wanted to use computers and Arabic. WinText was the first application supporting right-to-left text (Arabic) given to the mass market; it supported bitmap and Postscript fonts (TrueType was not yet available) and it constituted the unique and standard applications that all users working with Arabic on a Macintosh platform were using.

Two years later, Diwan, another company involved in this field, developed a desktop page layout application called *Al Nashir Al Maktabi* (based on Ready-Set-Go), truly enabling the Arabic desktop-publishing revolution. Despite the fact that Ready-Set-Go was a limited application, Diwan scored well because it entered that market first and because it made an effort to bring to the users of Arabic several new Arabic fonts with higher reproduction qualities than the standard fonts available through the pre-existing Apple-WinSoft partnership WinText. In light of growing competition from the likes of Diwan, WinSoft decided to enlarge its offering for Arabic users and to create a desktop publishing application to compete with Diwan: Aldus PageMaker ME (Middle Eastern).

One of PageMaker's greatest attributes was in how WinSoft understood that Arabic-language applications needed to come with extra fonts, so WinSoft proposed several fonts within the PageMaker ME package, which were licensed from various manufacturers and calligraphers. Initially available only in PostScript, the software kept up with the times, making itself compatible with TrueType when Microsoft started offering TrueType as an alternative to Postscript.

PageMaker ME's primary contribution to Arabic typography was the ability to provide users the freedom to move Arabic documents back and forth between the Mac and Windows platforms. At the time, this was not a simple procedure; each platform had its own character encoding and sets of fonts. PageMaker ME had conversion filters and a common Mac/Windows font that permitted switching back and forth between the two platforms, although it was far from being a smooth operation. PageMaker ME also allowed Arabic users a rich font called DecoType Professional Naskh, which had many more glyphs (approximately 800) than what the other technologies (PostScript and TrueType) could support at the time (less than 254 different glyphs). Lastly, the application featured the "DecoType setter," helping users manipulate these new, advanced fonts as well as proposing alternate glyphs to users based on the context of usage (an essential aspect of truly functional and accurate digital Arabic typography, as we shall see).

Diwan and WinSoft competed for years over the Arabic desktop-publishing markets. Diwan achieved more penetration in the industry of media, while WinSoft had a bigger market share in corporate usage. WinSoft had the privilege of a strong relationship with Adobe, and over time has been able to adapt to Arabic several well-known Adobe applications like Photoshop, Acrobat and Illustrator, which Diwan could not compete with.

The InDesign Hegemony

WinSoft's adaptation of InDesign to Arabic was a mature, well-tuned move. The Middle East version for both Mac and Windows created a master application for Arabic users. Neither Diwan with *Al Nashir*, nor Layout (Lebanon) with Quark X'Press and Arabic XT, were able to measure up to such a technical achievement. Support for InDesign ME reached an unprecedented level because of these undeniable attributes: TrueType and PostScript support, true bi-platform document exchange, possibility to use on one platform fonts originally designed for the other platform, support of Arabic XT proprietary fonts, import of various file formats, strong typographical control, a strong marketing strategy.

Tasmeem

The plug-ins and fonts that comprise Tasmeem – which means "design" in Arabic – further Winsoft's commitment to working with Adobe InDesign to optimize technology in order to best replicate Arabic textual traditions as contemporary fonts. The ability to achieve such integration permits designers the freedom and flexibility to work with Arabic as if they are working with the calligrapher's pen, honoring the revered calligraphic traditions while also keeping up with contemporary graphic design and typography trends. Through analysis of pen strokes

24

25

26

Teaching To Read
In this model we used an existing elementary school primer as printed in Beirut in the late 1980s. We selected eight words and designed two-page spreads to show the potential of Tasmeem for educational productions. We introduced the theme of shape variation as an educational concern. Tasmeem is new and unique in offering perspectives to teach all aspects of Naskh.

24, 25 Tasmeem education samples that show selected words plus their explanations taken from various pages of the orginal. The lemmata are presented in Tasmeem Naskh and the explanations in Tasmeem Emiri with colors indentifying each letter.
26 Sample of elementary school primer.

55 | Talking About Arabic

a clearly structured set of rules allows Tasmeem users to express the enormous variability of Arabic letters.

In order to provide these advanced capabilities, WinSoft has developed Tasmeem on top of the ACE (Advanced Calligraphic Engine) technology created by DecoType after many many years of research.

Created by Thomas Milo, Mirjam Somers and Peter Somers, ACE represents the characteristics of an "essential" Arabic script. Such a project was first endeavored hundreds of years ago by Ibrahim Müteferrika, a Hungarian Protestant who lived in Transylvania but fled to the Ottoman lands and converted to Islam. In light of the advent of the printing press and its inability to facilitate the contextual nuances of Arabic calligraphy, he was given the charge of designing an Arabic typeface thats' greatest virtue was that it privileged the intrinsic nature of Arabic. Müteferrika's efforts yielded the best Arabic typeface of the time, based on how calligraphers treated individual Arabic letters.

In creating ACE, Milo, Somers and Somers have based the technology not on the letters but on the pen strokes, which are the bits and pieces that bring Arabic texture to life on the page. The DecoType team deconstructed Arabic into a collection of tabular information, which of course apes the way computers function, reconciling the long-standing rift between Arabic calligraphy and printing and on-screen technologies. Instead of being hemmed in by limitations of the maximum vertical heights of the Latin alphabet, the tenets of ACE liberate Arabic from the confines of Western typography, paving the way for a new global era of Arabic typography and graphic design.

DecoType

Writing in Arabic relies on very systematic behavior, and those in the business of developing digitized Arabic fonts must analyze and reproduce this systematic behavior typographically, in the name of accuracy and understanding. Typographical designers typically want predictability, templates and features.

DecoType's technology permits designers the freedom to design Arabic fonts that match the intricacies and nuances of hand-written Arabic calligraphy and, more importantly, of high-end typography, because DecoType follows an approach that differs from the one adopted in OpenType, which is based on Latin typography. For quite some time, because the market did not demand anything different than the status quo, innovation was not required, or even embraced. Typesetting manufacturers like LinoType certainly kept up with technological advances, but there was no need for them to reconsider typographic practices when it came to digitized Arabic typography. But, as the need for proper Arabic fonts has grown over the past twenty years, so too has the need for Arabic fonts that catch the texture of Arabic, as opposed

to just echoing it. DecoType's Arabic Calligraphic Engine (ACE) does just that by paying close attention to the actual characteristics of Arabic scripts, rather than be content with compromising them.

DecoType's approach has created a far higher level of abstraction with the creation of ACE, breaking down the graphic representations of Arabic, not words, not letters, not sounds, or syllables, but letter blocks: groups of connectable letters.

ACE corresponds with the history of written Arabic, making it totally capable of conveying the contextual aspect of the language. Consider this: early written Arabic employed only fifteen basic shapes to represent thirty consonants. Early Arabic manuscripts, read today, are very ambiguous because of this, but this is also the written language's core foundation. Over the years, on top of written Arabic's skeletal structure, diacritic marks and vowels have been introduced; ACE allows these to be attached independently, so Arabic fonts can, the same as their hand-written calligraphic origins, react to context, resulting in the most authentic rendering possible. The ability for a font to react to context also maintains the most important aspect of Arabic writing: its connectivity. Within specific contexts, meanings change, as do how the meanings are presented in lettershapes; this is because all Arabic letters can fuse and be manipulated in any number of shapes. Never before has a digital technology been able to replicate this crucial element of hand-written Arabic.

ACE's technological template – the fluid responsive nature of fonts created with this technology – eliminates a great deal of repetitive and tedious work, leaving linguistic and orthographic aspects of the written language intact, permitting font designers to concern themselves only with the creation of new Arabic fonts that best, and most accurately, represent the traditions of Arabic calligraphy.

The DecoType Alef-Beh-Jeem templates may appear simple at first glance, but they are in fact comprehensive and very well organized in a typographical and a didactic manner. They implement Arabic typographic practice as well as the Unicode Standard – as it is conceived and not as a glyph list. To make ACE design possible with templates, they set up a thoroughly researched mandatory typographic glyph list. Then, with Tasmeem, dropping or using a feature is now in the hands of the end-user, where it belongs.

Designing ACE Fonts

While ACE technology allows for highly sophisticated fonts which generate letterforms that are contextual by default, DecoType makes it easy for type designers to create new fonts for ACE. They have prepared three templates which incorporate the entire logic required for full Unicode support (not only of Arabic but also of other

THE DECOTYPE ALEF TEMPLATE

THE DECOTYPE BEH TEMPLATE

THE DECOTYPE JEEM TEMPLATE

27 There are three levels of templates: Alef, Beh and Jeem.

languages that use the Arabic script) and for giving letters a shape which fits into the given context.

The designer's task is rather simple: The designer fills the glyph cells of a Design Template with letters and strokes which in combination form letters. (ACE is based on the idea that a glyph can be a complete letter, but also be a letter-segment.) In a second step, he moves on to a Calibration Template which offers additional cells in which he calibrates the positions of strokes so they connect well, and adjusts positions of dot and vowel attachments. There is no need to assign correct Unicode codepoints to glyphs, or to write features, since Deco-Type has done this already. This eliminates a great deal of repetitive and tedious work, permitting font designers to

concern themselves only with the creation of new Arabic fonts that best, and most accurately, represent the traditions of Arabic calligraphy.

In the Alef Template, letters connect on the baseline as in most Arabic OpenType fonts. This makes it easy to fill the Alef Template with an existing OpenType font's glyph complement. And still, fonts produced from the Alef Template have full Unicode coverage and provide all attachments, which cannot be said about similar OpenType fonts. The Beh Template, in addition, covers various assimilated and dissimilated forms of the tooth of beh (and seen and sad) – 'the dance of the beh' – which increase legibility and offer a greater variety of contextual forms. (Figure 27)

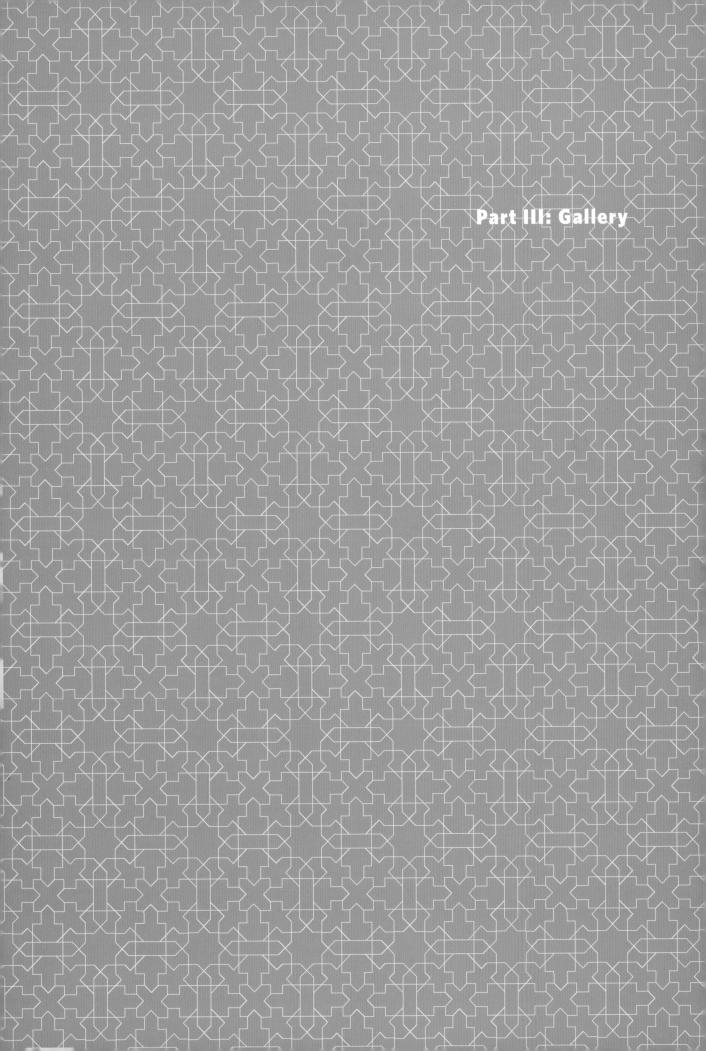

Part III: Gallery

Alba Japan
Antoine Abi Aad

The Academie Libanaise des Beaux Arts (ALBA),
University of Balamand organized a workshop, a cultural
bridge linking Japan and Lebanon.

The purpose of the workshop was to promote Japan
and Lebanon mutually. In Lebanon, the promotion of
Japan is through the introduction and deepening of the
Japanese culture, art and design. In Japan, the promotion
of Lebanon would be through the work of Lebanese
students and their personal vision of Japan.

Religion is always present when we deal with Arabic,
and it is a pity, I guess. I think beautiful religious works were
done in the Arab world through centuries of Islamic art, but
it is high time to tell the whole world that Arabic is not only
religious! This is what we tried to do in the workshop, using
a theme: describing Japan, in Arabic. Arabic heritage should
be a starting point and not a destination.

01

01 Guy Asmar
Direction Artistique, Artistic Direction; Third year
Original title: Anti (in Arabic), comme je te vois
English translation: You, as I see u
Explanation: Based on some unclear images (cliché) that I have in my head,
I used Japanese, Latin and Arabic typography to draw a Japanese girl, my
Japanese girl.
02 Isabelle Baaklini
Direction Artistique, Artistic Direction; Third year
Original title: Aasfouren bi hajar wahad (in Arabic)
English translation: Two birds with one stone
Explanation: It is such a coincidence that two proverbs from different parts
of the world meet through a common saying. Japanese people and Lebanese
people are reading the same message, each people through their native
language.
03 Maria Chame
Direction de Création, Creation Direction; Third year
Original title: Souniaa fi loubnan (in Arabic)
English translation: Made in Lebanon
Explanation: Illustration of Carlos Ghosn inspired by a poster of Ikko Tanaka.
04 Christiane Ziase
Direction Artistique, Artistic Direction; Third year
Title: Meiji Restoration
Explanation:The transition from Edo era to Meiji era: opposed to the enclo-
sure of Edo.
for 250 years, the Meiji restoration is considered as a chain of events that led
to enormous changes in Japan's political and social structure.
05 Karen Feghali
Direction Artistique, Artistic Direction; Third year
Original title: Misconception
Explanation: I know very little about Japan and I found it would not be accu-
rate to represent such a rich and complex culture in one poster. Here I found
the one thing I, as a Middle Eastern, can identify myself with. We are as much
misconcepted as the Japanese.
06 Andre Mcheileh
Direction Artistique, Artistic Direction; Fourth year
Title: Communication is cultural
Explanation: First impressions are not always true. Sometimes it needs a
double take!
07 Paola Gemayel
Direction Artistique, Artistic Direction; Fourth year
Original title: Communicate
Explanation: It doesn't matter who we are and where we are, what matters is
how we communicate.

02

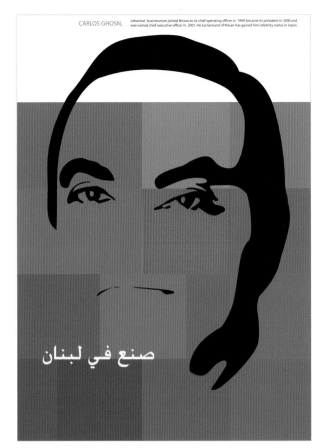

CARLOS GHOSN, Lebanese businessman, joined Nissan as its chief operating officer in 1999, became its president in 2000 and was named chief executive officer in 2001. His turnaround of Nissan has gained him celebrity status in Japan.

صنع في لبنان

03

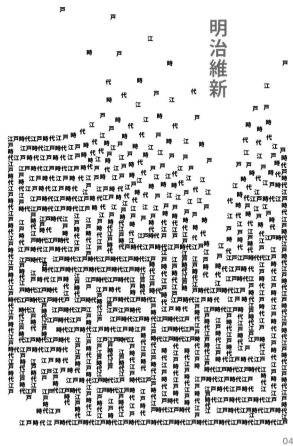

明治維新

04

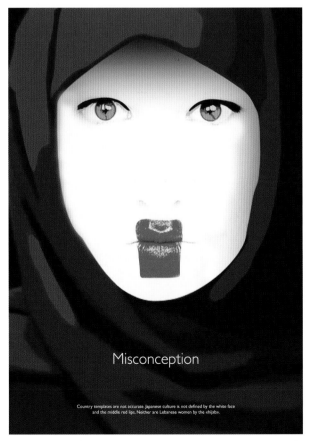

Misconception

Country templates are not accurate. Japanese culture is not defined by the white face and the middle red lips. Neither are Lebanese women by the «hijab».

05

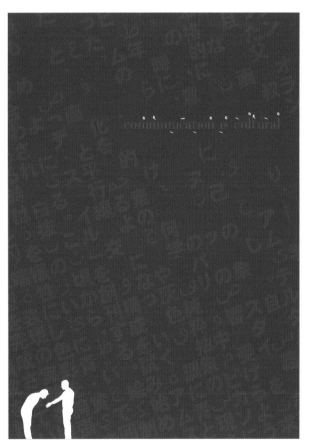

communication is cultural

06

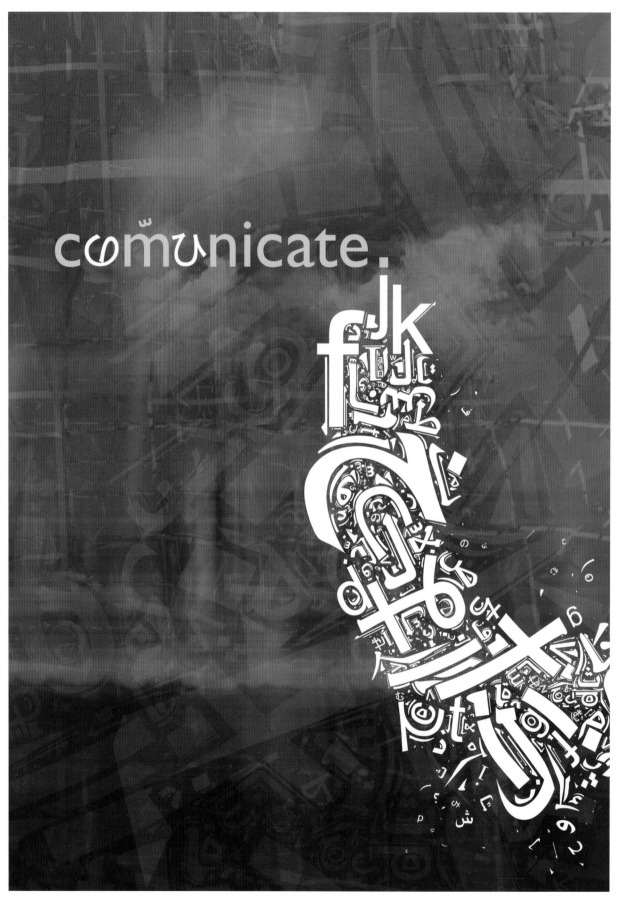

comunicate.

التَّواصل.

Ad-Diplomasi

السنة الحادية عشرة ـ العدد رقم ١٢١
كانون الثاني / شباط ٢٠٠٨
المحـــرر ريـمون عطاالله

Year 11, Issue Number 121
January/ February 2008
Editor Raymond Atallah

Ad-Diplomasi
News Report

تقرير اخباري عن العالم العربي والشرق الاوسط يصدر في لندن

هيمنة...

تتحرك الازمة اللبنانية المتفاقمة والمتداخلة مع النسيج الاقليمي والدولي حول محور بالغ التعقيد يختصر ازمة الانظمة العربية كلها بدون استثناء. ما يجعل من لبنان اهم نقطة مفصلية في العالم في الوقت الراهن. فهو على صغره بات يوازي بقية العالم. كما قال الشاعر الصوفي الكبير محي الدين بن عربي: «وتحسب انك جرم صغير/ وفيك انطوى العالم الاكبر». فاذا كانت اسرائيل هي عصارة العالم الاكبر. فان لبنان قد هزمها وسط ذهول ذلك العالم الذي بدا وكأنه طاش سهمه فطار صوابه.

وسر هذه القصة ان اللبنانيين اكتشفوا القانون الذي يحكم العالم اليوم. وهو قانون الترابط والعلاقة الجدلية بين الهيمنة الداخلية والهيمنة الخارجية. ذلك ان رفض اللبنانيين للهيمنة الداخلية من قبل فريق معين على بقية الافرقاء يجعل الهيمنة الخارجية شبه مستحيلة. ولهذا فشلت حتى الآن جميع المداخلات والوساطات العربية والاجنبية. وربما كان ذلك اهم درس تعلمه اللبنانيون من الهيمنة السورية السابقة. ورسب فيه بامتياز كل من تصور انه من المحتم ان تكون هناك هيمنة خارجية اخرى تحل محل الهيمنة الخارجية السابقة لتثبيت الهيمنة الداخلية.

وفي هذا سر «الحصار» الذي تفرضه القوى الدولية والعربية على العماد ميشال عون لأنه اول من اكتشف هذا القانون وطبقه وعمل به. بحكم تجربته المديدة وتبصره بالمستقبل. فلم ينتقل من هيمنة قاومها طويلاً الى هيمنة لا سبيل الى مقاومتها. فميز حركته عن اهل الهيمنة الداخلية المنتقلين من هيمنة خارجية الى هيمنة خارجية اخرى. بحكم تلك العلاقة الجدلية.

وفحوى هذا القانون هو انه اذا خضع اللبنانيون الى الهيمنة الداخلية. فانهم خاضعون حكماً الى الهيمنة الخارجية. لأن الهيمنة الخارجية بطبيعتها هي الاقوى. فاذا كانوا خائفين ومتعبين من مقاومة الهيمنة الصغرى. والاضعف. فانهم لن يستطيعوا مقاومة الهيمنة الكبرى والاقوى. ويبدو ان اللبنانيين حتى الآن ليسوا خائفين ولا متعبين!

يشير العائدون من دمشق الى ان القيادة السورية تعيش اجواء حرب. لم تعد مستبعدة على الاطلاق ما بين سوريا واسرائيل. اذ انها تعتبر اغتيال عماد مغنية في قلب العاصمة السورية اختراقاً اسرائيلياً جديداً لأمن سوريا وسيادتها. بعد الاختراقات الجوية الثلاثة السابقة. قبل نحو سنتين على «عين الصاحب». ثم التحليق فوق قصر الرئاسة في اللاذقية. وكان الرئيس السوري بشار الاسد وعائلته داخل القصر. ثم قصف المنشأة العسكرية (قيل انها للمواد النووية) في دير الزور قبل بضعة اشهر. وتشعر دمشق بأن تكرار الخروقات الاسرائيلية صار يحرج القيادة السورية كثيراً امام الشعب السوري الذي بدوره بدأ يشعر بالاحباط الممزوج بالسخرية. من جراء عدم الرد على هذه الخروقات. خصوصاً ان «الخرق الامني» الاخير باغتيال مغنية يشكل تحدياً خطيراً للأمن السوري. فهو حصل في كفر سوسة احدى ضواحي دمشق التي تقع فيها بعض مقرات الاجهزة الامنية والعسكرية السورية. الاستخبارات العسكرية. والاستخبارات العامة. وأمن الدولة. ووزارة الدفاع. وغيرها من المقرات السياسية والحزبية والاعلامية. ويضيف العائدون من دمشق ان الامن السوري مرتبك. وهو يجري التحقيقات والتحريات من اجل كشف مرتكبي عملية اغتيال مغنية ومن يقف وراءهم. لأنه اذا فشل في ذلك فقد يتعرض لهزة كبيرة يمكن ان تفرض على القيادة السورية اجراء «نفض شامل» لكل الاجهزة الامنية. لأن سهولة حصول مثل هذا الاختراق. لا يمكنه فقط ان يطال مسؤولين كبار في ضيافة الدولة السورية او في زيارتها. بل يمكنه ان يطال ايضاً قيادات سورية في اي وقت (!) ومع ان اسرائيل لم تعلن مسؤوليتها عن الاغتيال. لا تلميحاً ولا تصريحاً. فان اعلامها لم يتردد في الاقرار بمسؤولية «الموساد» عنه. حتى ان صحيفة «يديعوت احرونوت» ذكرت في سياق تحقيق لها عن الاغتيال ان منفذيه انتقلوا من روما الى دمشق بجوازات سفر ايرانية مزورة.

When the Layout "Speaks" the Logo "Dances"

Ad-Diplomasi, a political news report covering Middle East affairs, was founded in London in 1996 by the Lebanese journalist Raymond Atallah. It is published monthly in Arabic and English, available only by subscription.

Since its first issue, *Ad-Diplomasi* has been met with interest and consideration amid the Arab world, either resident or expatriate, for two reasons. Its content, namely how it tracks and reports stories, fits perfectly with its layout and size.

The designers of *Ad-Diplomasi* considered the ways that the design could relate both the reality of the old heritage as well as contemporary technology. This was done by first establishing a specific style to the logo and then selecting the *Ad-Diplomasi* headline and body text font styles, resulting in an overall design that distinguishes *Ad-Diplomasi* from other publications, proving its uniqueness in terms of look and content.

The decisions to use blue for the color of the text emphasizes the pellucidity of its editorial approach. Furthermore, one's eyes feel more relaxed with this color. As per the size, it is the American A4 size, which is also used for political magazines. Hence, it is easier for the reader to take it everywhere. The designers stress that *Ad-Diplomasi* achieved success because the implementation was 100% accomplished exactly as stated in the design, unlike many magazines and newspapers where a random modification or an irritable transformation occurs, distracting readers from the articles.

How did the venture turn out?

From the outset it proved to be an innovative venture in Arab journalism. *Ad-Diplomasi* set out to provide a focus on sensitive topics and developments beyond what was available in the mainstream press, from which its editor and publisher, Atallah, brought over three decades of experience (at *As-Safaa* and *Al-Jarida* newspapers and the magazines *Al-Hawadeth* and *As-Sayyad*). "Conventional newspapers and magazines," explains Atallah, "are displayed on newsstands for readers to select. But *Ad-Diplomasi* seeks to select its readers, in the sense that it is directed at a specific sector of readers: those who have an influence on developments and decision-making."

The fact that it has lasted eleven years testifies to its success in establishing itself among the Arab media in professional terms. But these years were not without difficulties. Initially, the venture was not taken seriously, as the Arab world was unaccustomed to innovative approaches in the media. Some observers of the media scene, including admirers of the publication, doubted it would be able to survive or develop. But after the first five years this sceptical, though not negative, attitude receded. The publication established its following by shedding light on the underlying forces and currents that move

02

01, 02, 03 *Ad-Diplomasi*'s Arabic and English Editions. The design was based on blocks of text and hardly any images. Images were only used when important events occurred, such as September 11th and the assassination of Rafic Hariri. Using the unique Arabic logo in the Kufic style and the Arabic body text in the classical-modern Naskh style, as well as its English name in the Latin American Typewriter typeface under the title, *Ad-Diplomasi News Report* reflects its tradition, which goes back through decades of journalism experience, in conjunction with its contemporary look based on today's technological facilities and speed in obtaining and delivering the news to its readers. The logotype is based on a modern graphic shape of the eye that also reads "a" in Latin, which is the first letter of *Ad-Diplomasi* representing the sharpness and the continuous search for news.

من
الحقيبة

بلا ديبلوماسية
أمية..

AD-DIPLOMASI NEWS REPORT Monthly with periodic updates. Published by Focus Press (UK) Limited. PO Box 138, Chelsea, London SW3 5EX, England. Available only by subscription. This report is prepared for the private use of our subscribers. Reproduction without permission is prohibited. ISSN No. 13575465. R/N. 3171508 (England and Wales) Registered as Newspaper at the Royal Mail. Founded in London 1996.

Tel. +44 (0) 20 7286 1372
Fax +44 (0) 20 7266 1479
website: www.ad-diplomasi.com
e-mail: subscribe@ad-diplomasi.com

events and developments and probing them in depth.

Atallah recounts, "I felt that publishing *Ad-Diplomasi* out of a world media capital would help strengthen it in two ways. First by making use of the enormous amount of information and analysis available, of varying caliber. We gained a great deal of experience in distinguishing between what is correct and accurate and what is fabricated and contrived, in other words the difference between impartial media and the deceptive or manipulated variety. Secondly, London provided us with a window on the wider world, so as to better understand what makes it think about and behave toward the Arab world and Middle East as it does. One of *Ad-Diplomasi*'s attractions to its readers is that it publishes in translation by well-known non-Arab writers, who are given space to discuss their own countries' concerns in the Arab world. A number of Arabic magazines and newspapers do the same thing, but it has a different flavor in *Ad-Diplomasi*. Indeed, the difference between *Ad-Diplomasi* and the other Arabic publications that run articles by foreign writers and analysts is that we seek to focus them on particular topics specifically connected to key issues, rather than discussing any subject that comes to mind. We tell our foreign contributors what angles on a certain development we think would be of most interest to decision-makers in the Arab world, and they can sense from the reactions they get how much interest their ideas arouse both in their own countries and in the Arab countries."

The difficulties experienced by *Ad-Diplomasi* in its first five years seemed to vindicate the complaints made by some Arab publishers, especially book publishers, that the market for the printed word in the Arab world is inherently weaker than elsewhere. Some have suggested various explanations for this, such as that Arabs are not fond of reading. But this is not really the point, though it may have some truth to it. The principal reason is that there is not a single, free and open market in the Arab world, in addition to the various forms of censorship that are enforced in most of the Arab states. This reality, Atallah explains, "is a major reason why *Ad-Diplomasi* was conceived in its current form as a publication directed at a specific kind of subscriber. The prevailing practical and market imperatives in the Arab world made it unavoidable for *Ad-Diplomasi* to address what I call the 'known reader' as opposed to the 'anonymous reader.' Our experience over the past eleven years has been that such a publication develops a special relationship with its subscribers and an ongoing dialogue with them. Sometimes its readers turn into de-facto contributors, providing it with information and views and quizzing the accuracy or inaccuracy of what it publishes."

"In my view," Atallah continues, "it is this ongoing conversation which is the main gauge of *Ad-Diplomasi*'s success. This is what made it necessary to expand the

Ad-Diplomasi
News Report

Editor: Raymond Atallah No. 93 · October 04 · Year 8

The Lebanese situation as viewed from the US

Damascus believes that tightening its grip on Lebanon puts it in a better position for when Washington finally decides to "negotiate" with it about withdrawing its troops from and ending its political domination of the country. But informed American sources tell Ad-Diplomasi that this is a high-risk strategy whose costs to the Syrian regime could far outweigh its potential gains. By flying in the face of the feelings of the Lebanese and disregarding international public opinion, it has seriously undermined its position in Lebanon rather than strengthening it. Syria's decision to get President Emile Lahoud's term in office extended by another three years, instead of selecting a different pro-Syrian candidate to replace him, outraged both the Lebanese opposition and many of its own allies in the country - not least other figures who thought they had been promised the presidency such as Mikhail Daher, Jean Obeid, Robert Ghanem and others. Moreover, the Syrians dealt a heavy blow to the Lebanese prime minister - and by extension the Sunni Community for which his post is earmarked - by serving notice to former premier Rafik Hariri that he must submit his cabinet's resignation and decline to form a new government (the message was conveyed via Parliament Speaker Nabih Berri). This, coupled with the ever-deteriorating economic situation and the absence of any prospect of an upturn in sight, further antagonised a significant segment of Lebanese society. With the US and France having overcome their past differences and agreed on the need for Lebanon to regain its independence, the Syrian regime may have managed to silence its opponents for now, but it is in the process deepening its medium- and long-term isolation. Ad-Diplomasi's US sources add that they are perplexed by the role being played by President Bashar al-Assad's advisors. They suggest it could be likened to that of an enemy - given the old dictum that if you see your enemy digging himself into a hole, don't advise him to stop, and if you hear him make mistakes while speaking, don't interrupt him. The sources say that Washington intends to increase pressure on Syria and tighten its isolation in order to force it to change its strategy in Lebanon and start treating it in accordance with the rules of international relations as upheld by United Nations. As for the European countries - especially France -- which Damascus used to rely on to offset pressure from Washington, it has needlessly alienated them.

Damascus "willing" to come to terms with Washington over Iraq

The parameters of the regional standoff between the US and Syria have become somewhat clearer after the furore in Lebanon over the extension of President Emile Lahoud's term and UN Security

1

03

venture. Indeed it became imperative to do so, as much of what is in the publication deserves a broader and more effective coverage outside the Arab world as well."

The expansion of coverage referred to by Atallah was to start trying to reach an English-speaking audience, particularly in Britain, the United States, Canada and Australia, taking into account the speed of communication enabled by the internet, and subsequently a Francophone readership. But there have been a number of attempts by Arab publishers in the past to launch English-language publications, which eventually proved unsuccessful. These include the late Lebanese journalist Riad Taha's Geneva-based French-language magazine *Al-Afkar*, the magazine *Events* which the late Salim El-Lozi launched in London as an English-language sister publication for Al Hawadeth and Riad Shu'aibi's *Eight Days*.

The question then, why should an English-language *Ad-Diplomasi* do any better than these earlier efforts? Atallah replies: "The distribution is important in understanding why the publications mentioned failed and why I'm confident that my venture in this area can succeed. The English edition of *Ad-Diplomasi* and the French edition that we are preparing to launch in 2009 are an abridged publication that aspires to be accessible to officials, researchers and think-tanks in English- and French-speaking countries. The aim is to alert them to topics and arguments that they might be interested in probing in greater depth, rather than providing them with detailed expositions and ready-made studies. We are not trying to do what they do on their behalf. It is arguably a more important task to provide Westerners with pointers and insights about the Arab world than do the same thing the other way round. One generally hears fewer complaints about the Arabs' comprehension of the West than about the West's comprehension or rather incomprehension, of the Arabs."

Three years after its launch, does the English edition of *Ad-Diplomasi* have the potential to contribute to building bridges between the Western and Arab worlds by addressing Westerners in a language they understand? "The measure of success," says Atallah, "as I said about *Ad-Diplomasi* in Arabic is the extent to which the publication 'selects its readers' as I put it and provides them with material that gains their trust. By that gauge, I would not have thought of launching a French edition. There are many pitfalls in doing this, of which we are acutely aware. But the experience that has gained us the trust and engagement of a select readership has taught us to be discerning about the information made available to us, and to sift it sensitively and realistically in accordance with impartial journalistic practice. I admit that on a few regrettable occasions we have believed things that we should not have done, but we have learned from that, and we try to prevent any misinformation from getting

through by applying objective standards in dealing with the information we receive. In fact this happens to all publications, great and small. But publications like *Ad-Diplomasi* are better equipped to avoid traps, or evade them when they arise, due to the nature of their readership.

"Gaining the trust of readers with the passage of time is the foundation on which our English-language publication aspires to become a bridge of understanding and engagement between the Arabs and the West, by dealing boldly and seriously with sensitive issues and unconventional ideas. In my view, seriousness is the basis of building trust, and the building of trust was the basis of the success of *Ad-Diplomasi* in Arabic. Over the course of eleven years it has proven itself and brought something new to Arab journalism and media. If the English edition, or the French edition to be launched soon, can do something similar, they will doubtless become an important bridge linking the Arabs to the rest of the world."

Laha Magazine Case Study

David Learman

Client: *Laha* – Al Hayat Group
Agency: Creative Intelligence

Background – the Market

After several exploratory meetings and intense negotiations, Al Hayat, a London-based publisher commissioned Creative intelligence to create a new genre of Arabic-language, weekly, women's magazine with the aim of revolutionizing the market sector.

Before the advent of *Laha*, the Arabic, women's fashion / lifestyle magazine market was highly fragmented with only one or two, out of scores of published titles dominating the sector. Detailed research highlighted that most, if not all, the publications in the sector were effectively produced with the sole purpose of leveraging advertising revenues and that most publishers had little to no interest in delivering editorial quality or value. This was reflected in extremely low volume sales and cover prices to match, which, in turn, created a highly competitive cycle that all publishers found difficult to break out of. Many magazines were surviving on a financial knife-edge – making insufficient profits to fund and sustain any significant change. Most publishers were happy to maintain the status quo and to avoid any disruption to what was a comfortable marketplace where everyone knew each other and their place in the order of things. Above all, the majority were anxious to avoid any action that would have the potential to trigger a price war and, subsequently, have a negative impact on their advertising revenues.

With the exception of two titles, the whole sector including both weekly and monthly publications, contained between 85% -100% content acquired from syndicated sources or plagiarized (in many instances illegally and occasionally legally) from international publications and then translated into Arabic, which to some extent was a means by which to disguise the original source. By closely studying the market for a number of months, we found that the same features, stories and images were being churned across many competing titles and in some instances across those in the same stable. With the exception of cover design, little or no consideration was given to the quality of design and layout, which was limited to say the least. In terms of visual impact, all – apart from the two previously mentioned monthlies – employed a similar approach, eschewing any commissioned original editorial and imagery in favor of keeping costs to a minimum.

From a design perspective, the market was devoid of any publication that could stand its own against a European equivalent. Production values across the market, per se, were and still remain today, poor, reflecting the extent of the quality crisis the sector is in.

The Brief

Our brief was simple: to create a weekly, Arabic-language women's magazine that would revolutionize the market. One that would have strong appeal to a broad Arabic-literate, female audience and at the same time would attract advertisers by providing an advertising platform based on high-end design and production values.

The Objective

To become the market leader across the Middle East and Europe within five years

Strategy

The first step was to structure the project process so we could consider the entire publication sphere. This involved tasking separate but coordinated teams to plan and implement consumer workshops and competitor / market research programs, editorial content and structure, design and the visual appearance of the publication, art production, technologies, processes and practices and, finally, an executive team to coordinate and direct our recommendations and to liaise with the client's senior project team.

Research

Our strategy was consumer-centric – we went out and got to know the audience, and in particular, explored what they wanted. We conducted many workshops across the Middle East and in Europe with a sample of target Arabic-literate womenbetween seventeen and forty-five years of age. Their feedback clearly indicated that they had a huge appetite for intellectual, challenging and relevant editorial content – most read European magazines in order to keep up with the world at large. They all said, without exception, that they craved a magazine that could deliver the intellectual stimuli, fashion and news they needed in their native language.

A subsequent review of the competitive sphere highlighted that few publishers ever printed anything challenging – from either an intellectual, political or indeed cultural point of view. The reasons for this were understandable as most had a pan-Middle East circulation and wished to avoid any potential confrontation with state or religious authorities.

Concurrently, we planned and implemented a program of workshops and briefings with the client and their senior editorial and production managers in order to identify the challenges and establish the operations criteria and parameters involved in publishing and producing a weekly magazine.

The resulting feedback and information obtained from these meetings was critical to the design of the publication. Not only did we have to consider the current and potential future technologies involved but also the

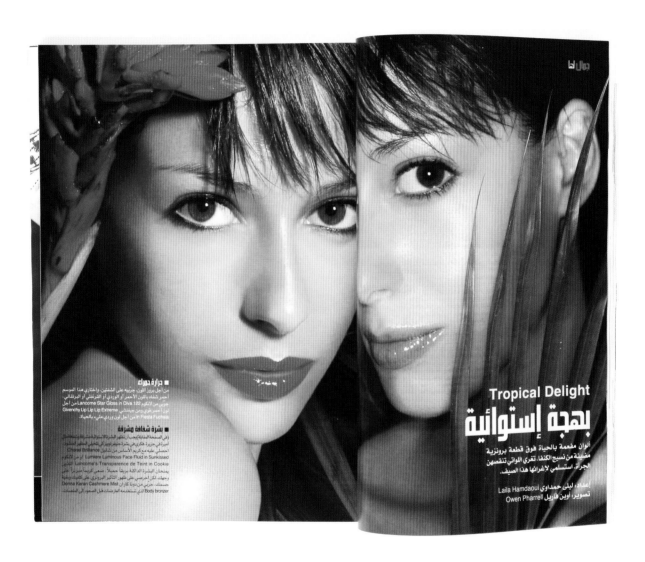

Tropical Delight

بهجة إستوائية

ألوان مفعمة بالحياة فوق قطعة برونزية
مضيئة من نسيج الكتفا. تغري اللواتي تتقصين
الجرأة. إستسلمي لإغرائها هذا الصيف.

إعداد: ليلى حمداوي Laila Hamdaoui
تصوير: أوين فاريل Owen Pharrell

■ **جرأة حمراء**
من أجل بروز اللون. جرئيه على الشفتين. واختاري هذا الموسم
أحمر شفاه باللون الأحمر أو الوردي أو الفرنفلي أو البرتقالي
جرّبي من لانكوم Lancome Star Gloss in Diva 122 من أجل
لون أحمر غري ومن جيفنشي Givenchy Lip Lip Lip Extreme
in Fiesta Fuchsia من أجل لون وردي مفعم بالحياة.

■ **بشرة شفافة مشرقة**
في الصفحة المقابلة تبدو ملامح البشرة والابتسامة مشرقتين ومشعتين
أميرة في جزيرة فكري في بشرة جبينك أو يك عن تحقيق المظهر المتفور
احصلي عليه مع كريم الأساس من شانيل Chanel Brillance
Lumiere Luminous Face Fluid in Sunkissed أو من لانكوم
Lancome's Transparence de Teint in Cookie اللذين
يمنحان البشرة الداكنة بريقا جميلا. سمى كريما مميزا على
وجهك. لكن احرصي على ظهور التأثير البرونزي على كتفيك ورقبة
حسنك. جربي جريني من دونا كاران Donna Karan Cashmere Mist
Body bronzer الذي تستخدمه العارضات قبل الصعود إلى المنصات.

ا ب ت ث ج ح خ د ذ ر ز س ش ص ض ط ظ
ع غ ف ق ك ل م ن ه و ﻻ ي ء ...

ا ب ت ث ج ح خ د ذ ر ز س ش ص ض ط ظ
ع غ ف ق ك ل م ن ه و ﻻ ي ء ...

ا ب ت ث ج ح خ د ذ ر ز س ش ص ض ط ظ
ع غ ف ق ك ل م ن ه و ﻻ ي ء ...

01 Boutros *Laha* Light, Medium and Bold alphabets

mindsets and methodologies of each of the editorial, art and production teams. We also took this opportunity to instill the importance of maintaining editorial and design integrity and quality consistency over a long term, while at the same time delivering freshness, individuality and spontaneity to the publication on a weekly basis.

Without doubt, one of the biggest challenges that resulted from our internal meetings was the issue of the paper quality. This involved finding a source of hundreds of tons of the preferred paper, a protracted circle of discussions with paper mills around the world and subsequent multiple recalculations of the financial model with the client's finance team. Thereafter, further discussions with the publisher, the production team and a short-listed selection of preferred printers with regard to delivery, warehousing and printing issues.

To ensure the integrity of our recommendations and to affect a smooth and efficient handover, Creative Intelligence was responsible for producing both the prototype advertising edition No o and inaugural full production edition No 1. We embedded all the client's publication personnel within our own project design teams for three months prior to the launch to benchmark the design and the practices and processes we had established but also to effectively transfer know-how and communicate and *Laha*'s core brand values.

Design

Editorial

One of the primary editorial prerequisites was to establish an appropriate intellectual and affordable platform. It was important that the read was mature, sophisticated and challenged the norm. Our research indicated that the magazine needed to cover a wide range of topics, from regional and local news bites through to features on taboo subjects, including violence in the home, the role of women in society, etc., as well as exquisite fashion and beauty features. Above all, the publication would be copy heavy, well researched and written to address carefully chosen issues with which the audience would immediately relate. We prompted the client to establish formal relations with various news agencies to ensure the integrity of the news content and recruited and briefed a stable of female Arab feature writers from across the entire Middle East region.

Design and Layout

Although the magazine is published entirely in Arabic, our design team did not include any Arab designers. This was a deliberate strategy aimed at designing a publication with a completely unique feel and tone. One of the most challenging tasks was to create a grid design that provided sufficient structure to maintain a consistent appearance while being highly flexible to allow section in-dividuality, creative flair and spontaneity and at the same time highly efficient, allowing ease of working within very tight deadlines. The success of the grid design is evident through its generic use across the entire publication, from complex multi-column news and society snippets through to clean uncluttered features and articles.

The publication is written and produced entirely in Arabic. A significant amount of time was spent choosing an appropriate family of fonts. We eventually chose Jarida for the text content throughout the entire magazine. The font sizes and leading were initially selected by the design team and tested by the art production team – to ensure a consistent page color and subsequently by the editorial team to provide feedback on legibility and readability. Ultimately, sample proof pages were consumer tested in workshops providing invaluable insights as to the amount of "design influence" that was acceptable to the target audience. As a result, we finalized a very small font size and tight leading which delivers a visual substance and communicates that the copy is intended to be a "substantial" read.

However, we could not find a commercial font that was perfect for headline and sub-headline levels. We therefore decided to design a family of fonts for the purpose. We wanted a font that was both completely new and outside normal convention. In conception and style it had to reflect a radical departure from traditional Arabic font design as well as contrasting and acting as a foil to the Jarida body text. Working with Boutros International, we created a completely new genre of Arabic fonts – Boutros Laha light, Medium and Bold. (Figure 01) Although closely protected, these fonts triggered a revolution within the Arabic font industry when they were first published – nothing similar had previously been seen. Today, we are proud to say that although there are several similar copies, there are also many new unique modern-style Arabic fonts being developed and a significantly wider choice is now available because of our efforts.

The masthead is one of the most important features of any mainstream magazine. To be selected from a shelf of many dozens of potential competitors, the masthead and cover must work hard to differentiate and attract the consumer. We created a mark in the form of a monogram for *Laha* based on a traditional calligraphic bamboo style and kept it very simple by reversing it out of a solid red panel. This combined with a clean layout together with a single superbly shot image of a personality or individual included in one of the main features, created a distinctly contemporary flavor. The masthead device was also cut as a key character for insertion as punctuations and break / end points in the body text.

The Results

Today, *Laha* is the world's most popular weekly, Arabic-language women's magazine.

Fluid Design: Arabic Portfolio

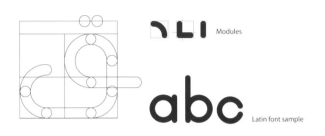

Modules

abc
Latin font sample

پ پ پ پ ج ج ج ج ش ش ق ق ق ق ق ق

تصميم الخط العربي حسب «فلويد»
Baroue Bold 30 pts

هَذِهِ الْجُمْلَة وَإِنْ كانَت بِهَذِهِ الأَحْرُف
Baroue Regular 24 pts

هذه الجملة وإن كانت بهذه الأحرف
Baroue Regular 24 pts

01

baroue
بروّي

baby
baroue
بايبي
بروّي

baroue
maternity
بروّي
مترنيتي

baroue
photo
بروّي
فوتو

baroue
kids
بروّي
كيدز

baroue
toys
بروّي
توير

02

03

04

05

01, 02 Baroue Arabic Typeface: MS Retail (Kuwait) commissioned Fluid to design an Arabic typeface adaptation from a Latin typeface used in the brand and throughout the Baroue Store in Kuwait. The Latin type has rounded ends and is of one stroke width. Few Arabic fonts are based on simple geometric forms (circle and square) and single stroke width such as here. (Original Latin brand designed by Gensler UK for MS Retail.)

03 Arabic/English Greeting Cards: These bilingual greeting cards were commissioned by MS Retail. The brief: create modern-looking cards, with a combination of Arabic and English typefaces.

04 Fine Fluffy Facial Tissues and Toilet Paper: Fluid designed the logo and packaging for Fluffy, a popular brand by the Jordanian company Fine Tissue Papers, Nuqul Group, that sells its products all over the Middle East.

05 Tahanina Logo: Tahanina, an event, planning company with branches all over the Middle East, approached Fluid for its Arabic/Latin logo design. The client's brief was straightforward: The logo should have a "simple" sans-serif Latin font for the name while using the Arabic name as the "visual."

Badr Al-Islami

Client: Badr
Agency: Lippincott

Launched in 2006, Badr Al-Islami is the Islamic banking offer from Mashreq, the largest privately owned bank, and one of the oldest banks in the United Arab Emirates. *Badr* is the Arabic word for the "full moon," and has a dual significance for the bank. Aside from the direct Islamic significance, the association with the moon helpfully described both the linkage and contrast with the parent Mashreq, meaning "sunrise" (or literally "the place where the sun rises"). Reference to the circularity of the full moon in the design for Badr was relevant, but not central.

The bigger focus was on the image that the identity should convey. Consumer research was used to explore the different motivations for Islamic banking, and the attitudes and preferences that Badr could best respond to as the Islamic arm of a well-known commercial bank, rather than a standalone Islamic institution. Complementing the traditional Islamic values of transparency and trust, the research explored personal service dimensions such as warmth and easiness, and performance dimensions such as dynamism, where Badr's offer could compete strongly.

The resulting design, reflecting Badr's brand promise, combines this commercial dynamism with traditional Islamic values.

One of the challenges of branding in the UAE is communicating effectively with so many cultures and nationalities, with a target group that cut across local and ex-pat Arabs and that large Indian Subcontinent community. Most research participants immediately read the Badr name in the Arabic symbol, but some of the non-Arab participants did not see it right away. When they did see it, it became all the more engaging; in this case the subtlety of the symbol for this part of the audience worked in the logo's favor.

Contributor Biographies

Antoine Abi Aad is Lebanese, a practitioner of judo and has always been fascinated by Japan. After he finished his DES in advertising design from the Academie Libanaise des Beaux Arts (ALBA) he traveled to Japan in 2001. In March 2004, he earned his Master of Arts in Visual Communication Design from the University of Tsukuba, where in March 2007 he also completed his PhD in Comprehensive Human Sciences, Art and Design. After seven years in Japan, Abi Aad returned to Lebanon to be a coordinator and a lecturer at ALBA. t.a@japan.com

Raymond Atallah was born in Beirut and graduated from Sacre Coeur's College. Joined the Military Academy (DCA division). Started his journalistic career writing for the newspapers *L'Orient*, *Al Jarida* and *As-Safaa*, and has since worked for *Al-Hawadeth* and *As-Sayad* magazines. His assignments have taken him to war zones in Africa, South East Asia and the Middle East. Atallah has lived in London since 1976. In 1996 he started *Ad-Diplomasi*. raymondatallah@london.com

Ian Bezer heads up the non-Latin font development in Monotype Imaging's UK office. He apprenticed as a compositor in the days of hot-metal typesetting and worked in the printing industry in England and Holland before joining Monotype in 1974. Since then he has been involved primarily in the creation and support of non-Latin typesetting systems and fonts. Arabic was the first exotic script he worked with and it is still his favorite. ian.bezer@monotypeimaging.com

Pierre Blangero is the Chairman and Chief Executive Officer of WinSoft, which he co-founded in 1985, and a member of the Board of Directors. He oversees the company's sales and management activities. Prior to founding WinSoft, Blangero worked in the associative field in collaboration with the Cooperation Ministry. He contributed to the development of public management computer systems (customs, public accounting) in various African and Middle Eastern countries. After fifteen years of experience, he decided to co-found, with Kamel Gaddas, a software company. Blangero holds an Engineering degree from the ENSIMAG at Grenoble, France. pblanger@winsoft.fr

John Boutros's roots in the graphic and publishing industries spread out over thirty-five years, covering Lebanon, Saudi Arabia, England and the United Arab Emirates. He started working in the advertising and newspaper business in 1974 and moved on to the boundless world of graphic design, transforming the problem-solving methodology of design into a career. His knowledge of technology and publishing helped him integrate unique solutions for graphic designers and publishers in the Arab world. He has focused from day one on improving the graphics industry in the Middle East. He founded Grapheast in Dubai in 1996, pioneered the first Middle Eastern image library, helped establish the largest library of Arabic OpenType fonts and helped develop specific solutions for the advertising and publishing industries. john@grapheast.com

Halim Choueiry is originally from Lebanon. He is the Icograda Vice President and a design educator and practitioner based in Qatar. He is currently an Assistant Professor at Virginia Commonwealth University, School of the Arts in Qatar. Having obtained a Bachelor's degree and two Master's degrees, he is undertaking a PhD in Design at Brighton University in the UK, with his research focusing on cultural mapping and cultural navigation in the emerging state of Qatar. Choueiry also maintains a strenuous focus in research activities as a collaborator with the Center for Research in Design at VCUQ, mainly contributing in the development of *The World Design Report* and the Design Zone in Qatar. He is dedicated to bringing about sustainable changes in the approach and thinking patterns of design in the Middle East and the Gulf region. hchoueiry@qatar.vcu.edu

Kamel Gaddas is the Senior Vice President of WinSoft, which he co-founded in 1985, and a member of the Board of Directors. After managing the engineering team for 20 years, Gaddas is now at the head of the Business Development department. This department aims at expanding and developing WinSoft activities. Gaddas was the driving force behind the transformation of WinSoft's original Macintosh software team into today's highly qualified globalization and localization engineering team, specialized in non-Latin scripts for both Macintosh and Windows platforms. Gaddas holds an Engineering degree in Computer Science from the ENSIMAG at Grenoble, France. kamel.gaddas@winsoft.fr

Allan Haley is Director of Words & Letters at Monotype Imaging. He is responsible for strategic planning and creative implementation of just about everything related to typeface designs and editorial content for the company's type libraries and Web sites. Haley is also president of the Board of the Society of Typographic Aficionados, and a past President of the New York Type Directors Club. A prolific writer, he has written five books on type and graphic communication and hundreds of articles for graphic design publications. www.fonts.com, allan.haley@monotypeImaging.com

George Kandalaft has been a university lecturer in statistics in Beirut, and a journalist, since 1989. He was editor in chief of *Apple Magazine for the Arab World* and *Tasmeem* magazine. Since 1995, he has been a Web developer and designer, specializing in on-line publications based on Content Management Systems (CMS), mostly in Arabic. He introduced Arabic and English support to the SPIP CMS, which originally only supported French, and created several multilingual sites using this system. **george@diwanalarab.com**

David Learman is a graduate typographer of the "old school" and founding partner of Creative Intelligence, one of the leading independent brand design consultancies in the Middle East. A contemporary thinker with a meticulous eye for detail, he has built and leads a highly talented and experienced consultancy team, which is responsible for the success of many pioneering brand solutions currently thriving in the Gulf region and beyond. Apart from his agenda of raising quality benchmarks in typography and brand design, Learman also champions the education and awareness of the designer's responsibility to environmental sustainability in the region and beyond. **david.l@creativeintelligence.info**

Thomas Milo, adventurer, linguist, typographer and inventor, is an associate member of the Unicode Consortium with which he was involved since 1988. He has provided seminal Arabic script tutorials – grown out of a series of internal briefings for the Microsoft Middle East Product Development group since 1992 – to dozens of Unicode Conferences. With these lectures, and with the full Arabic glyph set he researched and designed for the printed edition of the Unicode Standard, Milo single-handedly reversed the trend of industrial simplification of Arabic. He is partner in DecoType (with Mirjam Somers and Peter Somers), the team that has pioneered smart font technology since 1983 to maintain the integrity of Arabic typography. **decotype@gmail.com**

Steven Reef has more than thirty years of experience developing prepress publishing systems for international markets. At Compugraphic Corporation he served as software leader and architect of the Arabic and Persian EditWriter, Thai EditWriter and conducted feasibility studies for Hebrew and the languages of India. He held a leadership position at Atex, responsible for teams developing multimillion-dollar publishing systems and evaluation of PostScript for use in graphics composition workstations. In 1988, he co-founded Glyph Systems, which quickly became a preeminent developer of non-Latin fonts, Arabic in particular, as well as specialty calligraphic typefaces. Under Reef's management, Glyph was the first company to market scalable Arabic typefaces for MS-DOS, first Arabic desktop publishing for PCs, first to offer Arabic TrueType and TrueType Open fonts for Microsoft Windows and in collaboration with Boutros International, the first to offer families of Arabic type in eight weights. **stever@glyphsys.com**